Photography at Night

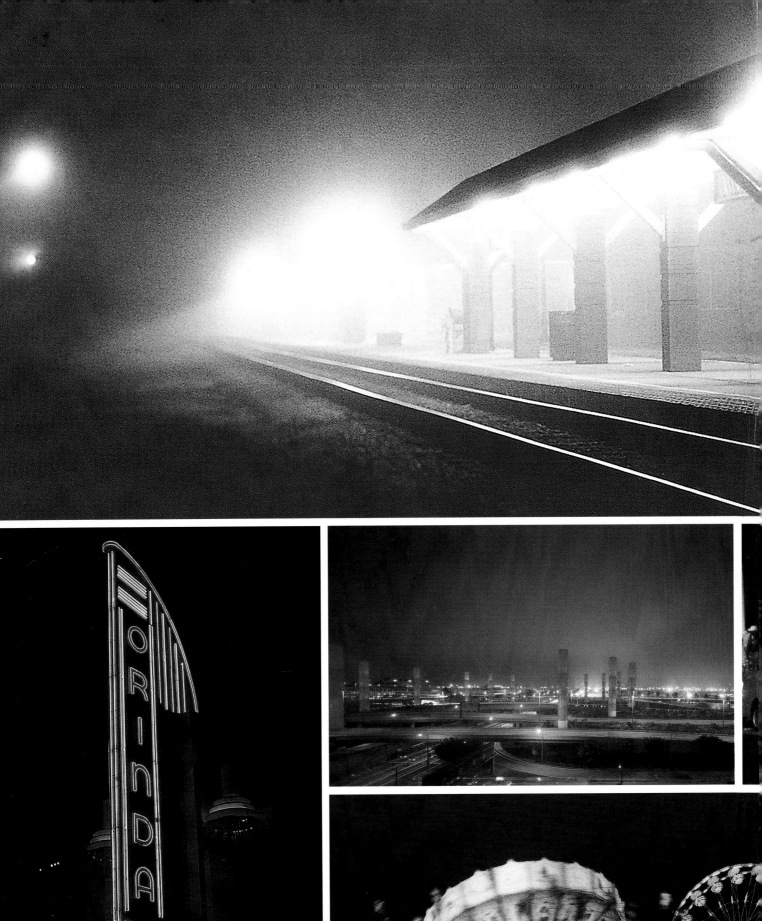

Photography at Night

Getting the most from low-light conditions

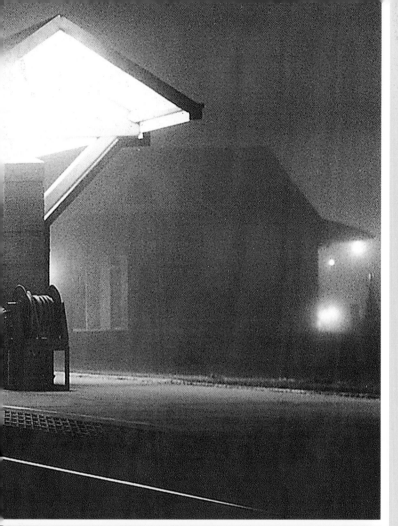

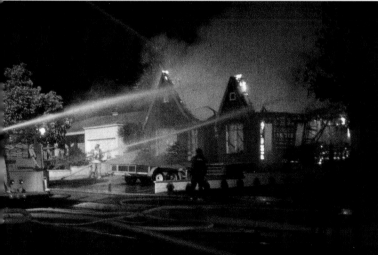

Richard Newman

Amphoto Books
An imprint of Watson-Guptill Publications
New York

First published in the USA in 2003 by Amphoto Books
An imprint of Watson-Guptill Publications
A division of VNU Business Media, Inc.,
770 Broadway, New York, NY 10003
www.watsonguptill.com

First published in Great Britain in 2003 by Collins & Brown Ltd
The Chrysalis Building
Bramley Road
London W10 6SP
Copyright © Collins & Brown Ltd 2003

1 2 3 4 5 6 7 / 07 06 05 04 03 02 03

Library of Congress Control Number: 2003105454

ISBN 0-8174-5015-7

Senior Editor: Nicola Hodgson
Editor: Ian Kearey
Design and concept by Grade Design
Designer: Anthony Cohen

Reproduction by Bright Arts, Singapore
Toppan, Hong Kong

This book was typeset using Rockwell.

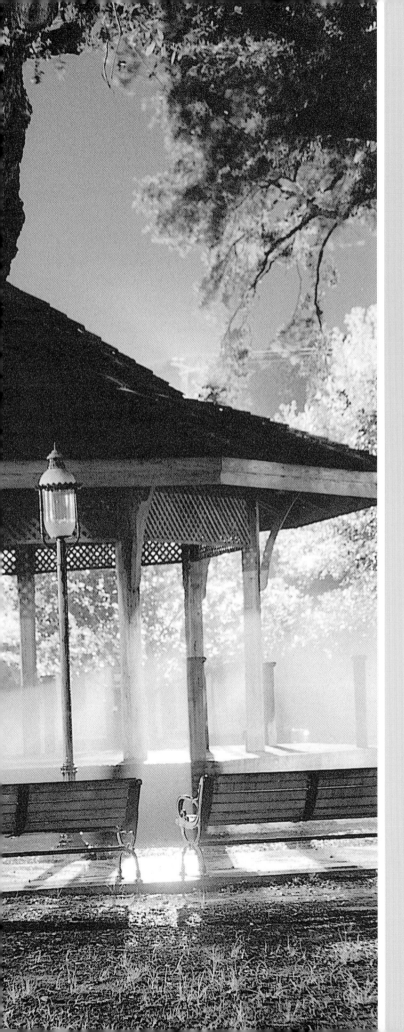

Contents

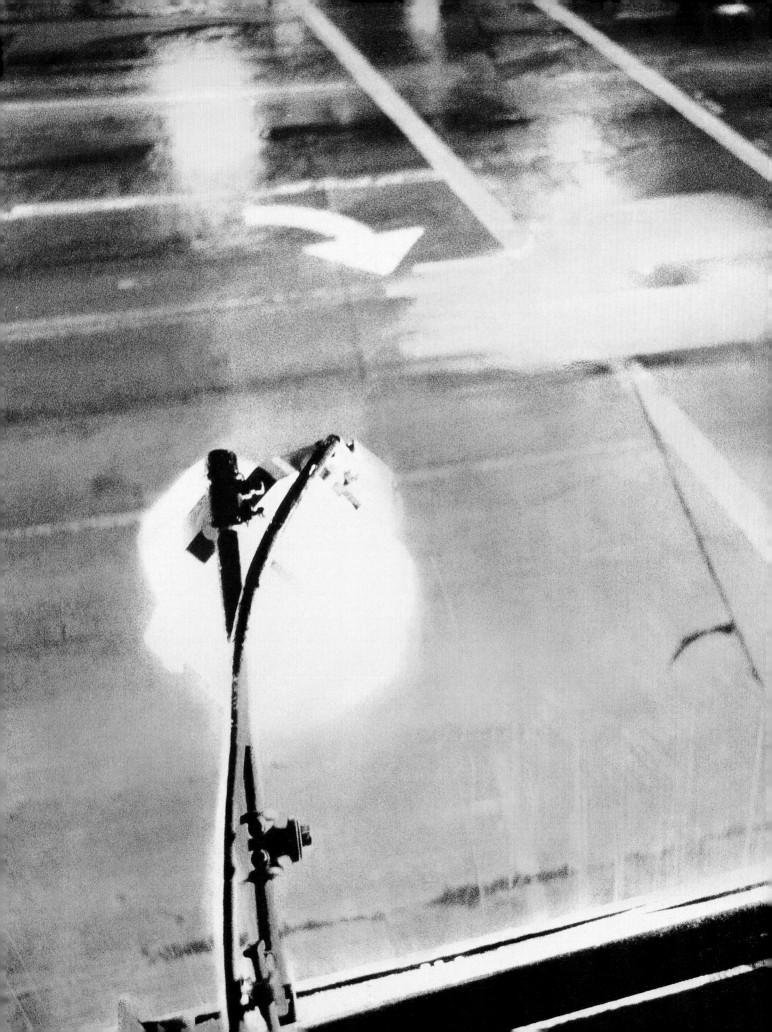

Introduction

This book is intended to be a starting point, an opening into the exciting and challenging world of night photography. The photographic process is a fascinating one, and night photography brings all of its best elements together.

Dennis Keeley Sunset Boulevard in the rain. On a rainy night in Los Angeles I made this photograph looking out the window of a famous music club, the Whisky a Go Go. Taken using a Leica M4 with 90mm lens and Ilford HP5 film.

Introduction

Exposures may range from as little as 1/125 second to more than 125 minutes, and the magic that occurs with longer exposures still takes my breath away when I see the results. Recording a subject in a low-light or night situation is one of the most exciting and creative uses of the photographic process. When we combine our photographic tools—the camera, film—with the possibilities of the darkroom, and the creative talents of the photographer with our creative talents, wonderful things truly can happen. Scenes that we perceive as sharp are blurred colors weaving together, and people literally disappear, while ghosts become common occurrences during daylight hours.

Night photography allows the creative camera artist to paint with the light that is there, to allow clouds to form silvery shapes and constructions. Over long exposures even unwanted elements in a scene can be made to fade away.

Left Using the camera at night helps you learn new ways of seeing and stirs your photographic imagination. Some camera users take pictures, but photographers working at night *make* pictures. Developing ideas and techniques that impose a personal and insightful approach on their image-making leads to photographs that express emotions and elicit reactions from the lucky people who get to see them. By applying many different techniques to night photography a lamppost, with clouds behind it, for example, can become a beacon with whipped cream clouds that blend and swirl.

This image was made with a Hasselblad camera, a standard 80mm lens, and Ilford HP5+ film, developed for standard contrast by using normal processing times.

Right Night photography is about ideas and new ways of seeing. During the 1994 Northridge earthquake, the area of Los Angeles that I lived in sustained heavy damage to the roads and neighborhoods. When I made this picture of the crumbled and fallen roadway support, I was not looking to create a clear, concise image, but one that reflected the way I felt at the time. This image was made on an extremely dark night with a Hasselblad roll film camera and a standard 80mm lens. There was very little contrast in the scene so expanded development of the negative was used. The negative was developed with an N+2 formula.

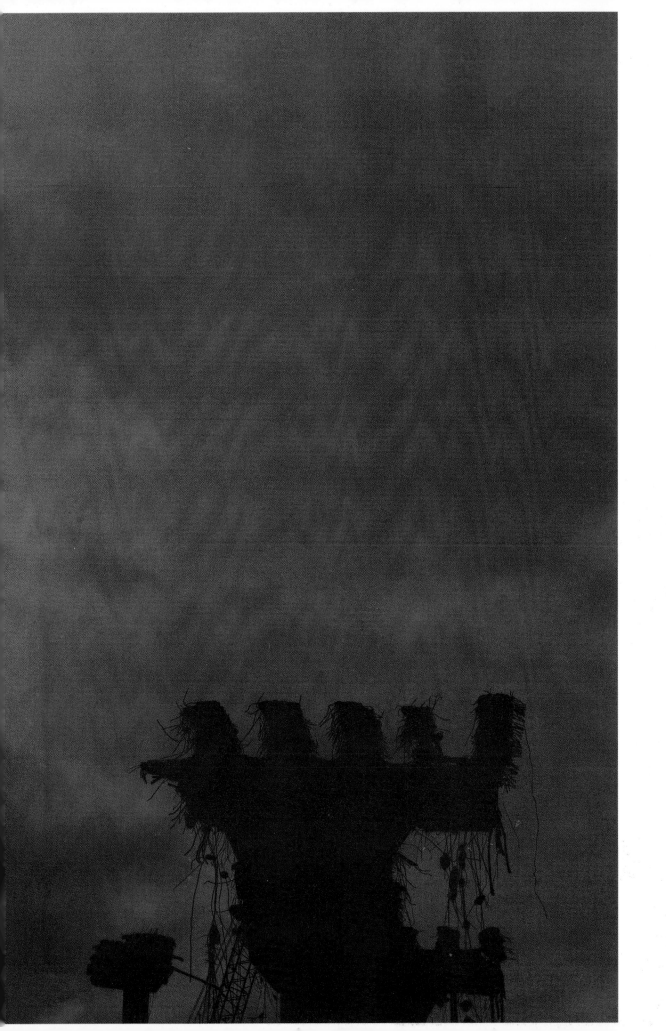

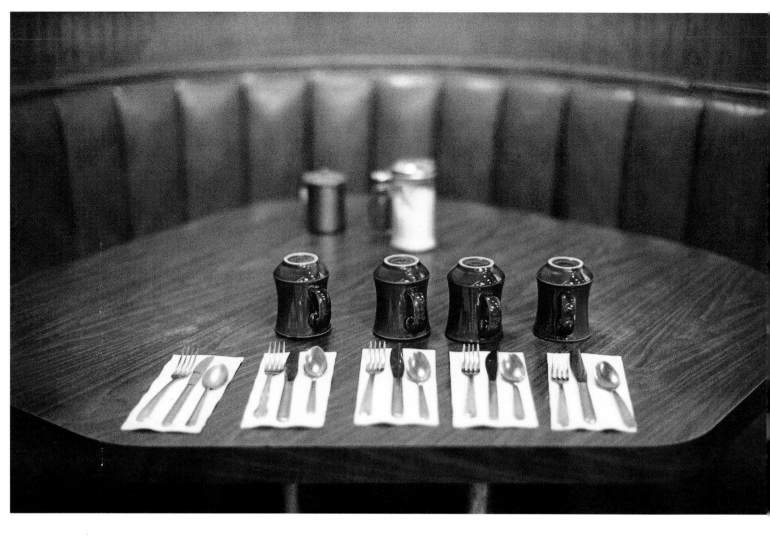

In this book, by following the assignments on pages 84–123, you will learn to experience and conquer the challenges that photographers often encounter when photographing at night or during low-light conditions. By making the best choice of the correct film and equipment, and understanding of the low light environment, you will have the confidence and background knowledge to go out and experiment to create dramatic and exciting imagery.

Golden Rules

First, I highly recommend using professional products whenever possible. This will guarantee that your film has not been sitting at the shipping yard on some dock in the sun for a year before you get a chance to use it. Second, it's very important that you maintain the highest possible standards in your processing. If you process the film yourself, use fresh materials. If using a lab, choose one of the highest calibre. Don't waste your time or money with poor workmanship in this area; it will compromise your

Above No More Coffee For You!
I was in a restaurant in Bakersfield, California, at about 1 a.m., on my way home. As I walked by I saw that the place setting at the end did not have a coffee cup; this was a grab picture made with my Leica and NoctoLux F1.0 lens. This image has been very successful in sales and with collectors.

Right One night in Bodega Bay, California (the location where Alfred Hitchcock filmed the movie *The Birds*), I had my own experience with a bird, which was gracious enough to stay sitting on an old piece of dock while a 15-minute exposure was made. In the daylight this would have been a very average photograph, but with craft and imagination it became an illusion with a story that could only be told with a camera at night.

This image was created with a Hasselblad camera and 150mm lens on Ilford HP5+ film. The lens brought the birds closer and compressed the image. The exposure was set for the bird to retain its detail; the film was processed with -1 development. If the film had been given standard or +1 development, all detail would have been lost.

ability to learn anything. Some one-hour processing places take great pride in their work and do a tremendous job; the lab doesn't need to be the most expensive, just one that has the best workers.

Finally, always try to process your film as quickly as you can after completing the assignments or tests. The easiest way to learn and improve is when you can see your results right away.

Finding Your Own Style

Night photography is challenging and very rewarding. It opens worlds to our viewers that only we, as photographers, can see or visualize. With practice and patience, those worlds are out there for us to discovery and record. Try to think outside of the box and develop your own style and ideas. A great photograph most often comes from a great idea—it very rarely comes from chance. It's also essential to be prepared and keep your camera with you; I can't stress

this enough. Sometimes at night surprises can unfold right in front of you; it is to your advantage to be ready and prepared to capture them.

Equipment

The images in this book were created primarily with the following equipment:

- Zone VI 4 x 55 Ultralight camera with 150mm F5.6 Schneider lens
- Zone VI Ultralight 8 x 10 camera with 300mm Nikon F5.6 lens
- Hasselblad 500 camera CM with 80mm Zeiss lens
- Nikon F100 camera with 24 f/2.8, 60mm Micro, and 80–200mm f/2.8 lenses
- Olympus E-10 digital camera
- Zone VI VC black-and-white enlarging system
- Apple Macintosh G4 computer
- Epson Perfection 1640SU scanner

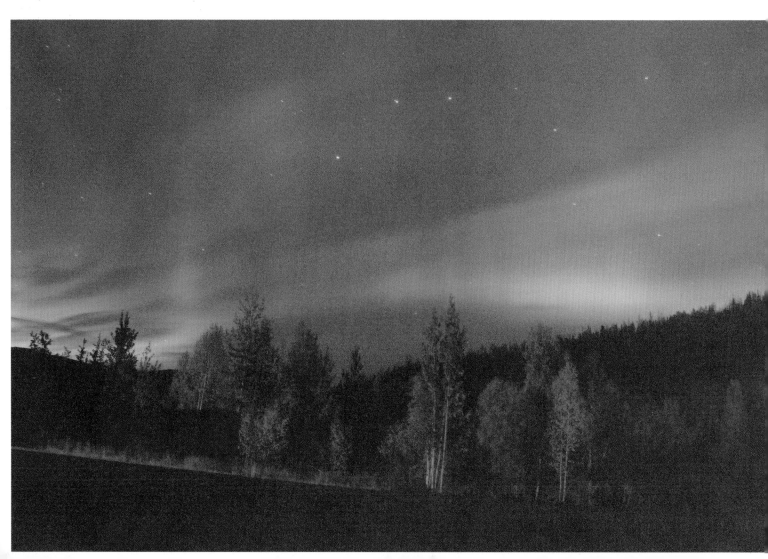

Above This is a digital capture employing the zoom feature on the camera. For this picture I set the camera to the slowest ISO setting (80), started with the zoom lens at its widest possible angle of view, and then, during the 3-second exposure, slowly adjusted the zoom to its longest focal length.

Many pictures in this book were created with a Leica M-6 with NoctoLux F1.0 and 35 F2.0 lenses.

Personal Thoughts

I am completely in love with the photographic process. I have spent years investigating ideas and going down too many wrong paths to even begin to recall them all here. On this journey I've made a bunch of bad pictures, but some of them came from good ideas that just needed to be worked out and converted into high-quality photographic images. I never tire of the chase of an exciting image and enjoy it when I see something that looks nothing like I have ever seen before. I think I have been successful in achieving this aim.

Left This photograph of the Aurora Borealis was made by Marianne Rowe and exposed for 15 seconds on a small tripod. She placed the camera in the middle of the dirt airstrip, which accounts for the red coloring in the trees. Using ISO 800-film kept her exposure short so that there were no distracting star trails.

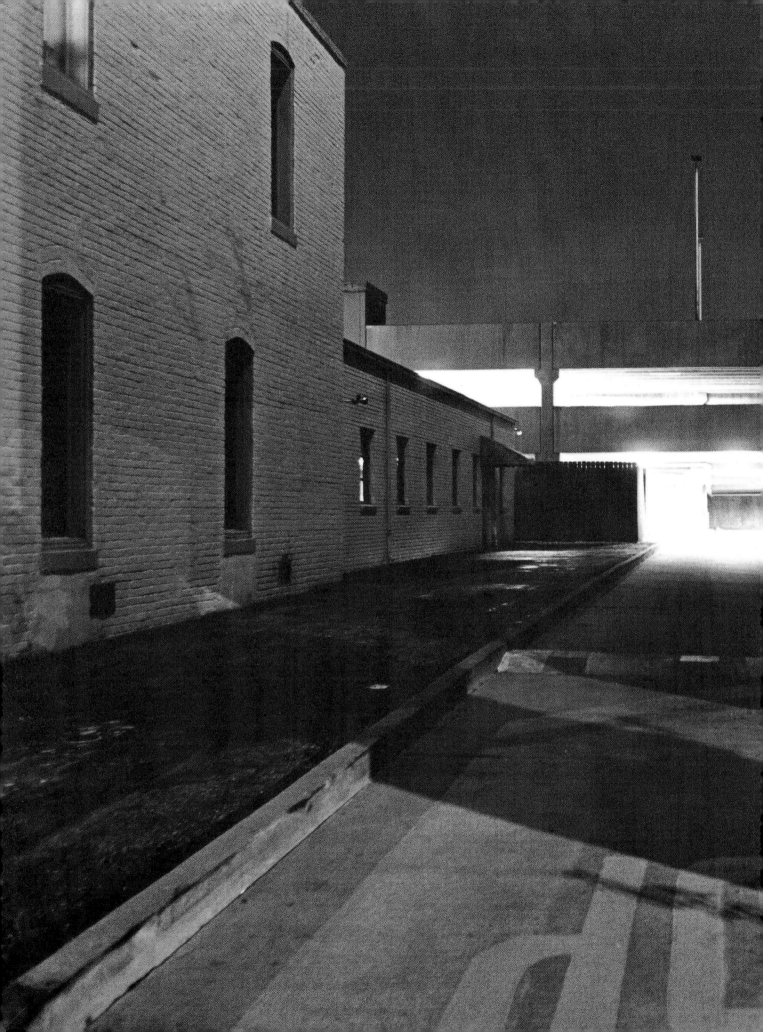

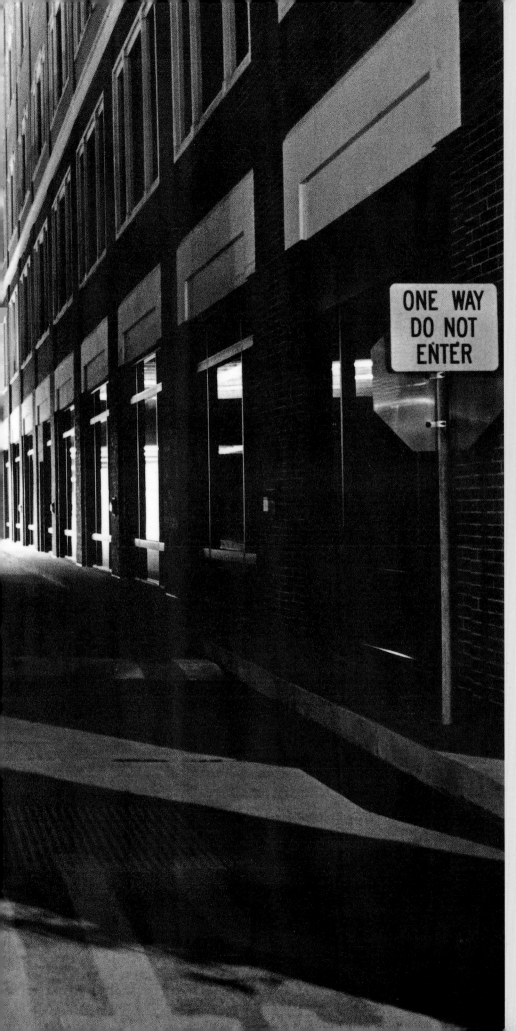

CHAPTER 1

Professional Portfolios

One of the things that makes photography so unique is that all photographers can express their personal opinions every time they click the shutter. Each of the photographers featured in this section has found his or her own voice with night photography by perfecting and understanding the craft and being bold enough to make photographs that express his or her visual ideas.

Sam Davis Do Not Enter, Pensacola, Florida, 1997

Richard Newman

I was drawn to night photography by the work of Bill Brandt, the master. His surreal imagery of England captivated my imagination and inspired me to start taking night. The magic that Bill Brandt caught in the shadows and streaming light was motivation enough to take my camera out at night with an open mind and a fierce determination. It became my goal to learn how to capture scenes with my own personal style.

I am also very interested in other aspects of photography—how to record motion and how to create a world of magic lodged somewhere between the film and the camera lens. Here, on the following eight pages, I would like to describe in some detail how the following images were created, with the hope that this will provide a more complete understanding of my motivations. I also hope to share the excitement that I feel when snapping the shutter or seeing the finished results of an image that is truly my own creation.

Above Airport Abstraction

If you travel through the United Airlines terminal in Chicago, you have to pass under one of the tarmacs. The airport authority decided to create some art under there with a neon installation—as you pass under the tarmac on a moving walkway, the lights change above you. This image was made with a Polaroid SX-70 camera. The film speed is close to 600 ASA, but the camera has a very average f-stop of about f/11. It took 10 seconds for this exposure to be made. During this time, I jumped up and down and spun around with the camera pointed over my head. I have had to answer some questions from the security folks several times in that airport.

Right Full Moon, Pacific Grove

Lots can happen after dark with movement, and water is one of my frequent targets. This image was created with a 4 x 5 camera and T-Max100 film. The exposure was 15 minutes at f/8. I love the whipped-cream look of the water. Many people think that this image was taken from an airplane, overlooking mountains in the clouds. If I was trying to create non reality, I feel I succeeded with this image.

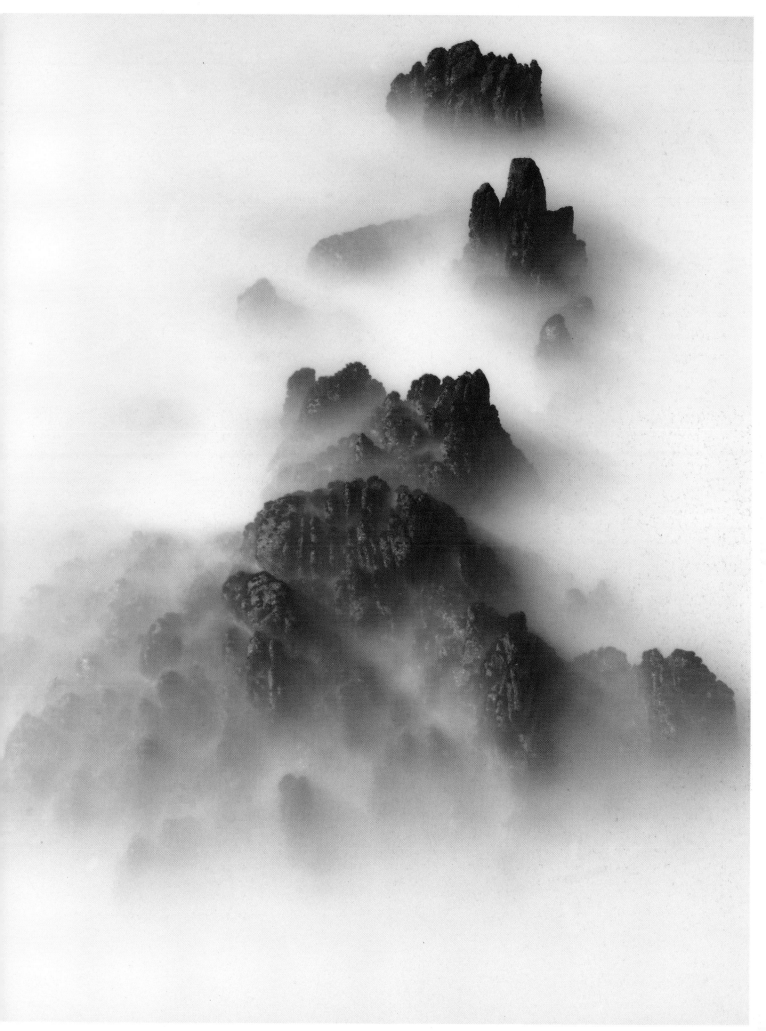

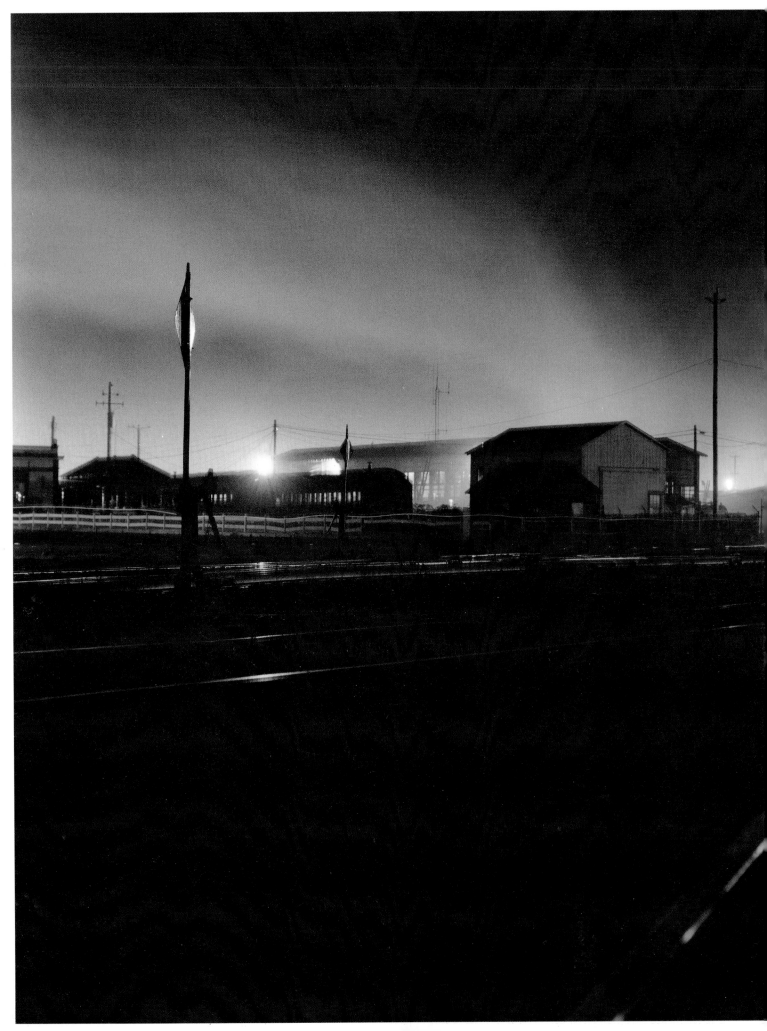

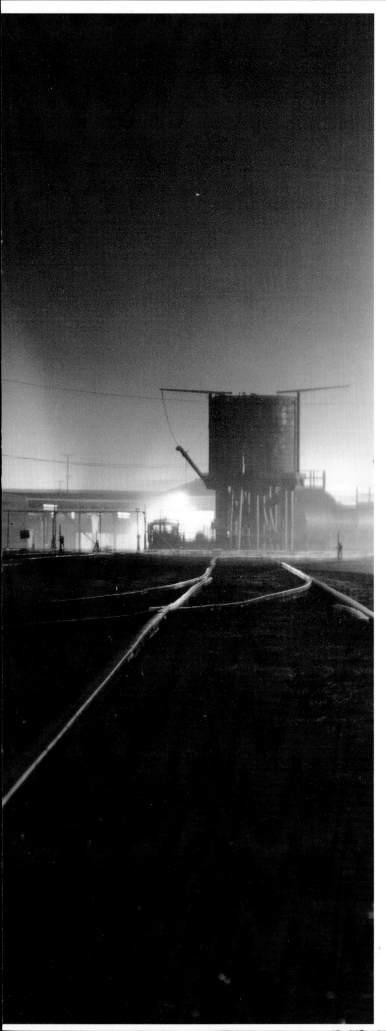

Above and Left Lumber Yard and Train Tracks
These images were made with my Hasselblad
camera on a very foggy and rainy evening in
northern California. I placed the camera very low
to the ground on the tripod, and used a 50mm lens
to allow for some depth of field. I like the train
tracks in the left-hand image, which draw me into
the center of the picture, and I love the fog and
mist coming from the lumber yard; these are
reflected against the low-hanging clouds. One
of the advantages of working at night is that not
everything needs to be in sharp focus—for
example, look closely at the train tracks. In the
darkroom I toned the image to produce the final
color, and to give it the same feeling that I had
when I was making the photograph.

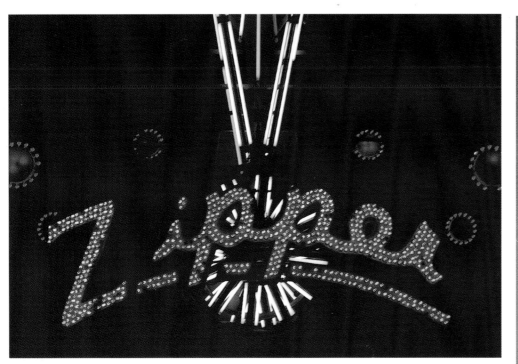

Above Zipper

It's hard to make a picture of this kind of subject matter without the clichés that generally come along with it. I used my 35mm camera on a tripod. This color image is made on transparency film, which has a very short exposure scale. Carnivals provide so much subject matter for night photography that sometimes I find it hard to isolate a particular image. I find myself walking around for 20 minutes before I begin to photograph, just to let the entire visual stimulus that I am receiving settle down.

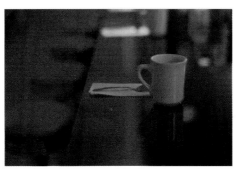

Above Red Cup

This image was made with my Leica and the NoctoLux lens. I was in an all-night diner in Palm Springs, California, at about 4 a.m., on my way to photograph a musical group in the desert at sunrise. The diner had a fifties décor, and the red neon in the room provided the red light that gives the picture its quality. The NoctoLux allowed me to make a spontaneous, hand-held image as I grabbed a quick cup of coffee to go. I love the very narrow depth of field this lens produces, which makes the background so soft and pleasing.

Right Sandbar and Waves

This photograph was made over two hours. The surf was extremely high that evening, with an approaching Pacific winter storm, producing a very fine white line where the sand meets the sea.

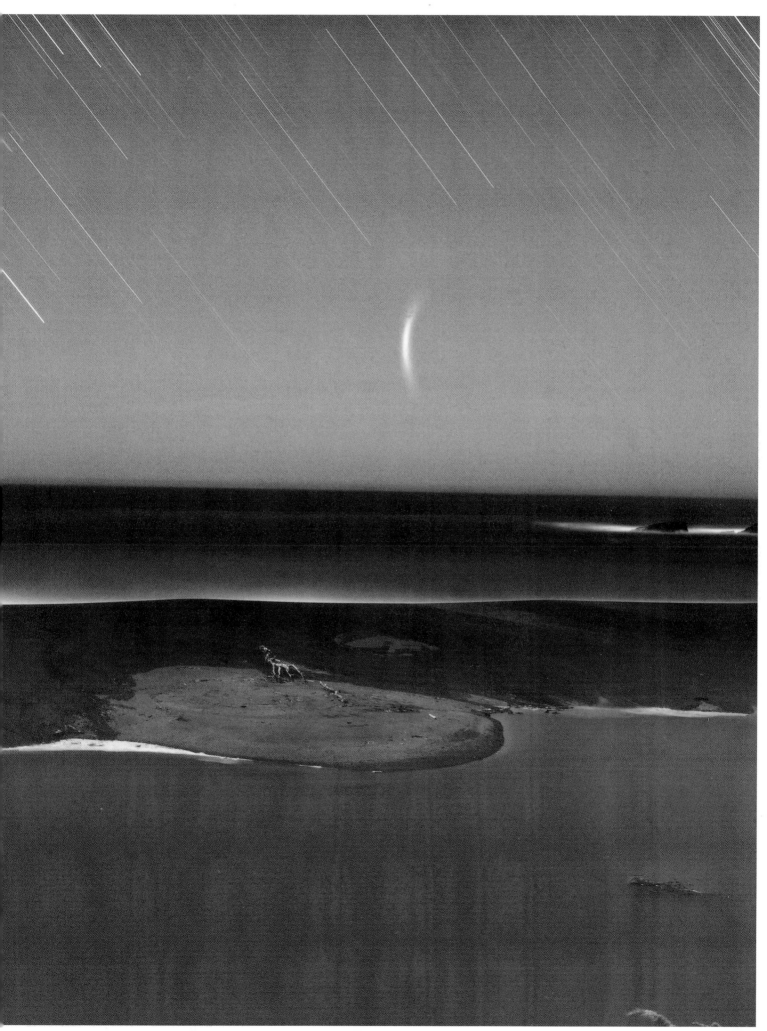

Above Self-portrait, Amusement Park

For my personal night work, when I work in color I am not so much interested in creating an accurate representation of the subject, as in putting in my own little touches. I love to see color just splattered on the paper and film. I made this picture with my WideLux camera, which has a lens that rotates and gives a 140-degree field of view—very, very wide! You can see my legs against the floor in the center of the picture. I have a basic idea of what I am trying to achieve when I go to make this kind of picture, but, in this case, success comes from shooting a lot of film and waiting for the results.

Above Two Nessies, or Four People in a Very Complex Relationship

This photograph was made with my 4 x 5 camera and T-Max 100 film. One reason that I like using this film for 4 x 5 is that it is available in film packs and eliminates the need to load film holders, which I inevitably get dust on, leaving big spots in the finished prints. The exposure of this image was one hour, which gave the water a very tranquil feeling. The logs looked like the Loch Ness monster when I made the print, which, I suppose, is proof positive that the monster and his girlfriend exist.

Right Bridge over the Savannah River

This photograph is a combination of two photographs made with my 4 x 5 camera. If you look closely, you can see the line or seam down the middle of the finished print. When I was making the picture, I made two negatives exactly the same and then combined them in my enlarger in the darkroom. The image is also printed upside down, because that was the way it appeared to me on the ground glass of the 4 x 5. Some photographers find it distracting to see the image inverted with a large-format camera, but I find that it helps to isolate my subject matter.

Dennis Keeley

I have never slept much, but that doesn't bother me. I am a little like the people in a horror movie—not a vampire, but definitely a creature of the night. When I found photography and discovered that I could stay up all night to develop film or make prints, I knew my vocation was calling.

In working at night I became familiar with the passing of the evening hours. These hours move at a pace different from the first twelve. It is a unique world without some of the distractions of daylight. People never drop by or call. My phone never rings in the night, except for drunken wrong numbers or quiet people who immediately recognize my voice as the wrong one and quickly hang up. The people who inhabit the night are different too. They do different jobs and have different attitudes about their jobs.

Making pictures at night requires inspiration, courage, patience, vision, and some technical knowledge. I used a tripod for all the pictures you see here, which allowed me to study my night compositions closely, setting height and tilt and looking at all my corners for compositional distractions. The tripod also lets me choose a depth of field that is right for the relationship between the subject and background; with it, I am free to use any shutter speed that will give me the proper exposure. In my photographs, the event, the relationship between all the elements, and the final presentation are all exacting.

We make photographs of the real world, but, in the end, they are separate from it and exist in their own purely photographic universe. Images of the night are even more possessed of some secret and mysterious quality than those of the day, being made in a time and space when most normal people are sleeping and unaware of all the nocturnal possibilities. People are usually surprised by the quality of night photography. Even students of photography are told when they start their studies that there isn't enough light at night to make good pictures. I learned early on that photography shows us a world that only a few stop to see, and even fewer make something of in response to what they witness. Nighttime can be the right time.

Right Fourth of July

This wasn't a gigantic, illegal, blinding blast, but a little fountain firework and an exposure of around 9 minutes. The streaks in the background are cars going past. The little firework lasted around 15 seconds, and the additional exposure painted in the street, houses, and sky. I always think that the crucial information in night photographs is the details.

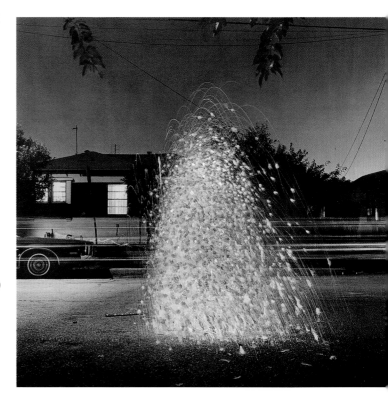

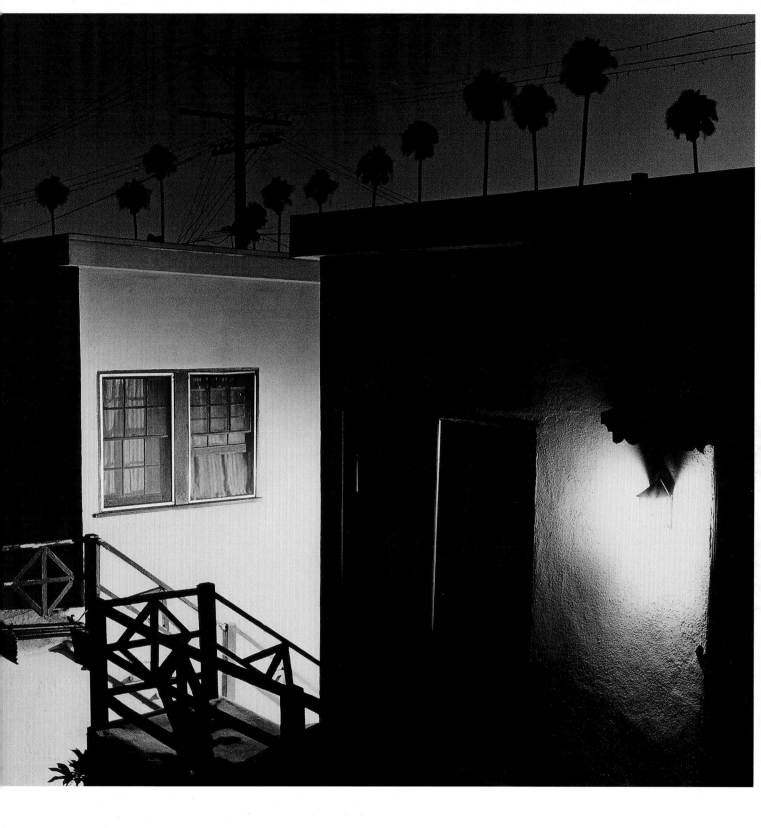

Above Downstairs

I was robbed at gunpoint at the bottom of these
steps. The hand-painted applications on all of
these photographs were part of a planned
process, as were the time of day they were shot,
the film and exposure, and printing. Each plan was
designed specifically for the end result. Planning is
an important part of making pictures.

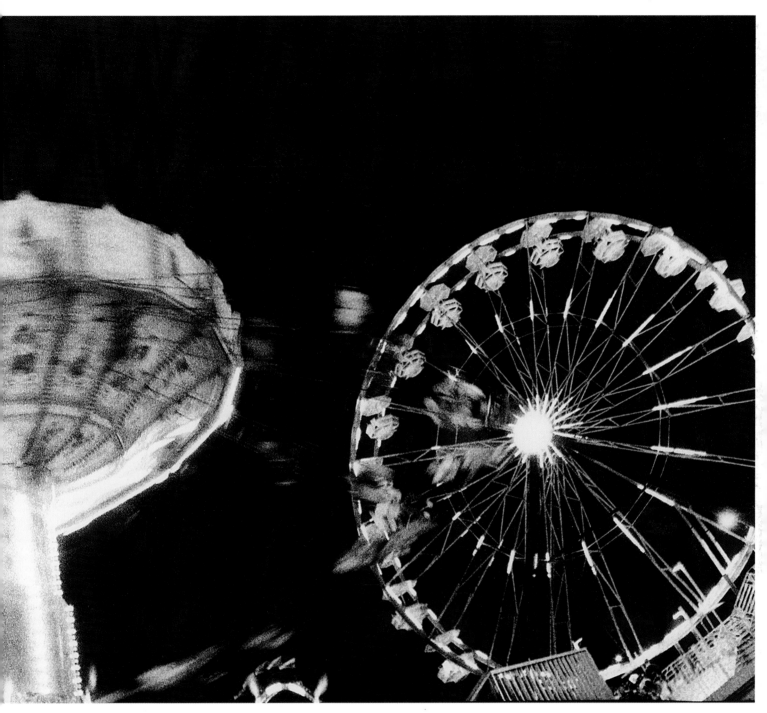

Above State Fair

This was shot with a panoramic camera, using Ilford Delta 3200 film rated at 1600 and developed in Ilford ID11.

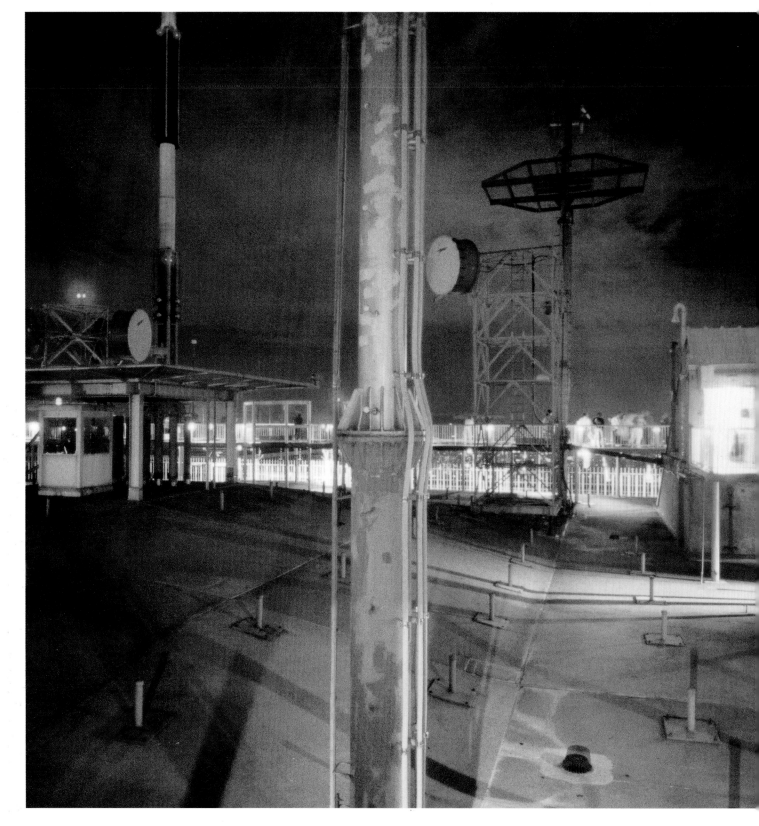

Above World Trade Center, South Tower, New York

This was a relatively short exposure of maybe 5 or 10 seconds, taken from what used to be the top of one of the tallest buildings in New York. This was shot on color transparency film, and the color is pretty accurate. The exposure was relatively short, so there wasn't much in the way of reciprocity failure. At the time, people wondered why I wasn't photographing the skyline. I just make my pictures.

Above The Pink House

I made hundreds of pictures of this house when I lived next door to it. An old woman lived there alone, and I would often see her wandering around the house, awake like me in the middle of the night. The exposure was about 5 minutes on a Hasselblad with an 80mm lens. I rate and expose my film normally so that I don't lose the shadow detail that is so important in hand coloring. I never have to push the film, so there isn't an exaggerated graininess to the image.

Keith Johnson

The process of photographing at night is fascinating—the learned visual process has to do with beginning to see what will reflect light and how much. Sometimes the surface will be highly reflective and (obviously) brighter than a lesser reflective surface. In the same way, dealing with large, black, negative spaces punctuated by positive marks makes for a very different way of looking at the world.

When I took these photographs I was teaching in Hamden, Connecticut, with my daytime hours taken up in classes. I would get home at around 6 p.m. and go out for an hour's walk to photograph. I had a great time on this project, although I am sure I disturbed and startled some people by flashing into the night. I worked on it for about six months through the winter.

At first I was fascinated simply with how things look, then how they relate to each other, then how I was able to affect the scene with longer and longer shutter speeds. I very much liked the pictures that began to twist the space and posed some questions about what and how. I began to make pictures that contained less and less information.

As I began to extend the shutter speeds, I found myself more involved in the picture-making process. I would often make 6–10 negatives of each picture possibility, hoping to get one that worked. The success rate was pretty low, admittedly, but the reward was high when a good one was made. With long shutter speeds, I could calculate what the "appropriate" speed might be to give a frozen look or to lighten the ambient light. The problem with a scientific approach is that discovery seems to be secondary—serendipity played a strong role in how my pictures would be made and how subsequent pictures would be made.

The work shown here was all shot using a Hasselblad 500CM and 50/4 Distagon, and was lit by an Ascor 2000 potato-masher strobe. I tried to make the discovery process as simple as possible, using limited equipment and film type. The strobe gave enough light to be able to work at between f11 and 16 with the subject matter 10–15 feet away.

I used Ilford FP4 film rated at 80, processed in Edwal FG-7. The prints were done on Polycontrast or Multigrade paper. The print size was 10 by 10.

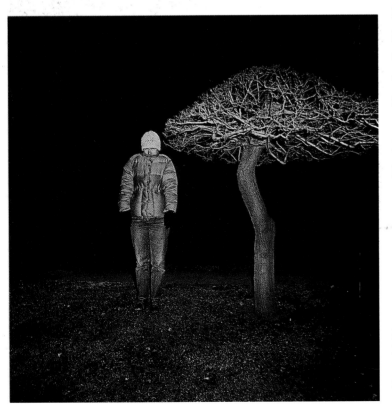

Left Becky in Hamden, Connecticut
F11 at 1/60 Straight flash. The darkness of the night caused the cropping of the tree. This picture is printed backward.

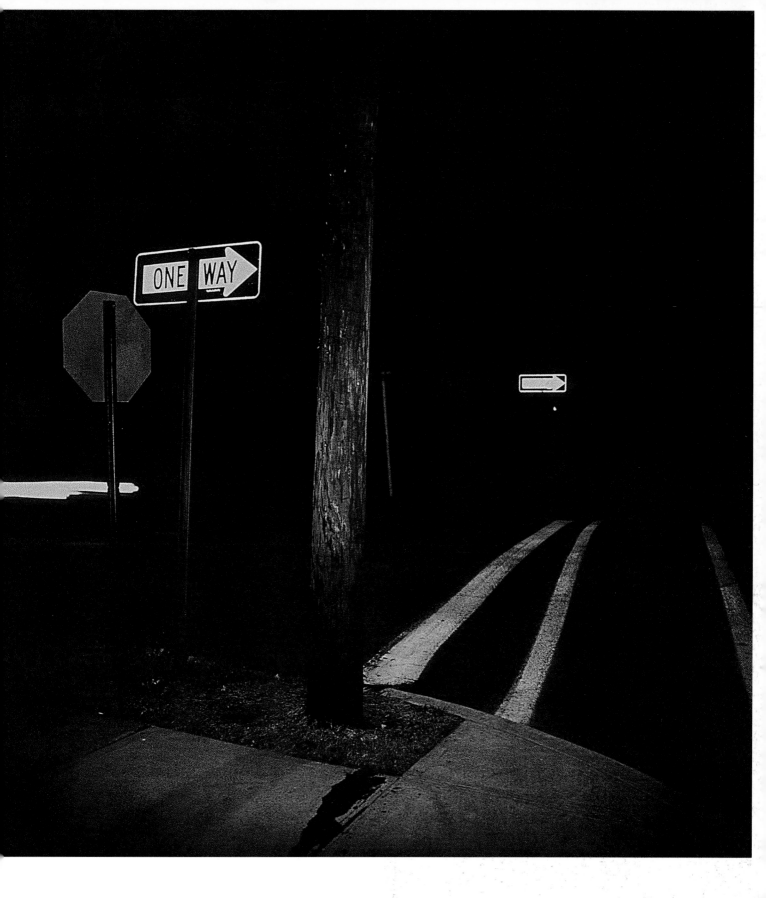

Above Hamden, Connecticut

This was taken at F11 at 1-2 sec. Hand-held.
The flash illuminated the reflective signs, the
telephone pole, and crosswalk. I was lucky that the
second "One Way" sign was glowing so brightly.

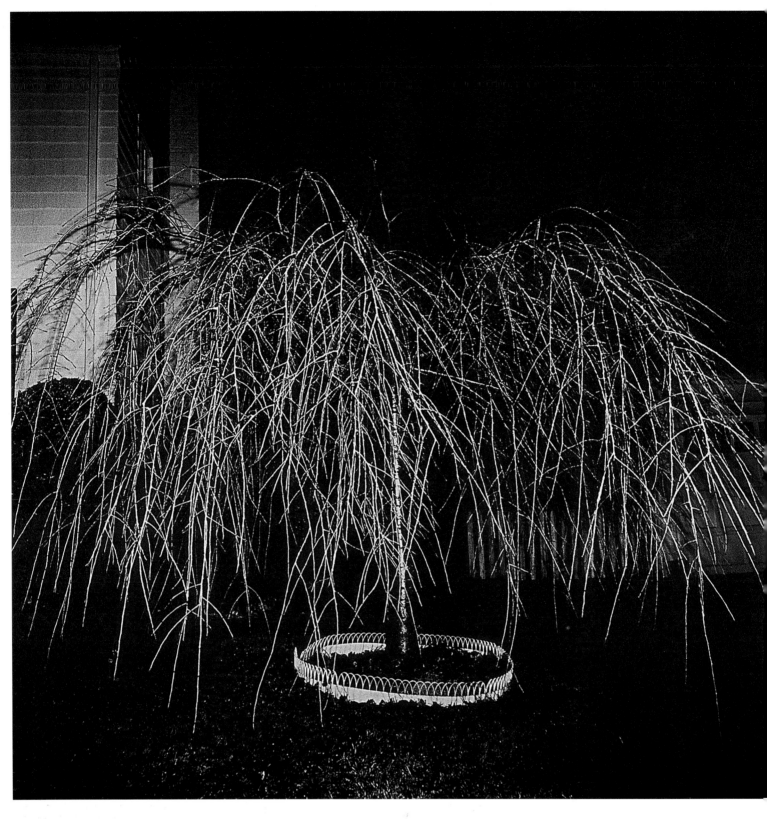

Above New Haven, Connecticut
Taken F11 at 1/30 with a straight flash.
The specular reflections off the branches
resembled a July 4 sparkler.

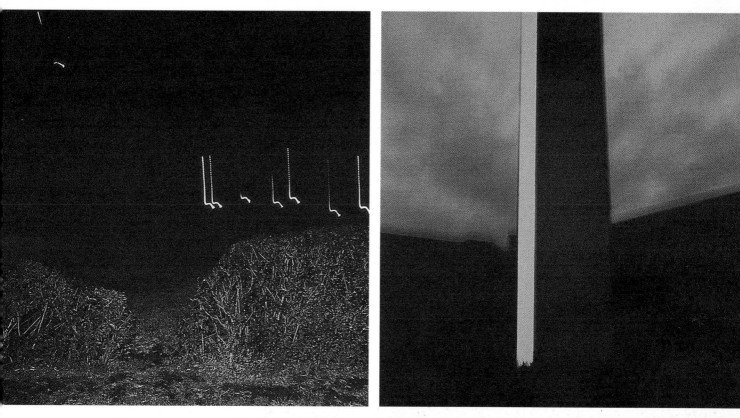

Above left Rochester, New York
F8 at ½ second with camera movement. The long
shutter speed coupled with camera movements
created the music note look to the lights.

Above right Victor, New York
F11 at 1 second with the camera supported by
the car.

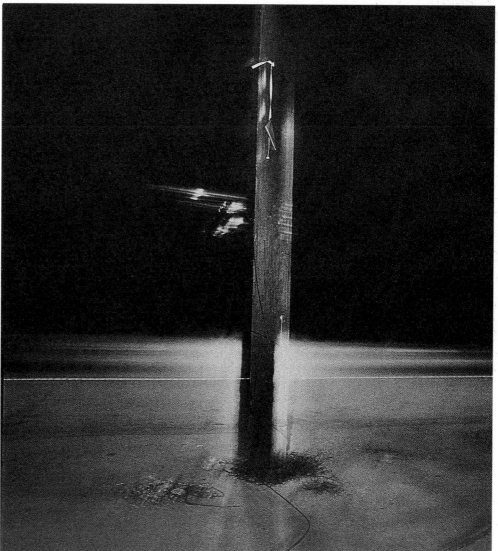

Right Texas on the Road
F11 at several seconds.
The long shutter speed caused the glow of the
light to occur.

Sam Davis

The night sky, with its overwhelming darkness, becomes a ceiling for a stage illuminated by streetlights and windows. It is a place where objects we normally disregard take on a life of their own. Even though the photos are devoid of people there is still the implication of one person, the photographer, alone in the street. That is what attracts me the most to shooting at night, the tension and the drama.

The unplanned results of a long exposure are not so much accidents as the product of carefully planning an unplannable act. I almost always use the same film, and I almost always shoot in the same manner. I look to find certain combinations of light that will render shadows and highlights the way I wish them to look, then try to get as much information on the negative as possible. Judging the amount of light from experience, I bracket a series of exposures, starting with a wide aperture, like f/8 (see page 51). These exposures, from about 30 seconds to 2 minutes, are my safety shots. I then stop down to f/16 or lower and shoot the same brackets, sometimes extending the exposure up to 3 minutes.

I have found that straight development works best for my purpose, but if there is a great deal of existing light, or if I am shooting sheet film and happen to see that the image is overexposed, I sometimes use an N-developer. I have found Pyro to be the greatest developer for night photographs—but I downplay the importance of depending on exotic techniques to achieve an image. I really feel the greatest part of photography occurs in the mind and intentions of the artist. If a person becomes too involved in image-making, he or she risks losing their voice in the process—although the lack of process can overwhelm a great idea and reduce a photograph to a simple illustration rather than an artist's statement.

Once I have developed the negative, printing becomes the area in which I greatly control the outcome. It is in printing that all the captured details are brought out. I tend to very selectively dodge and burn to heighten emphasis on certain areas, and others fade into the darkness. I feel that by being able to use the negative as a vehicle for the final print, rather than the strict framework for the image, the greatest artistic control can be achieved.

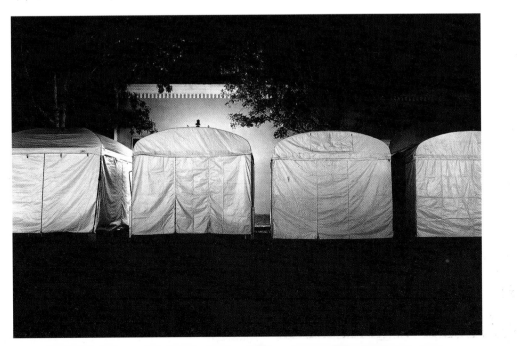

Left Tents
These bright white tents from an art fair seemed to just float in the street.

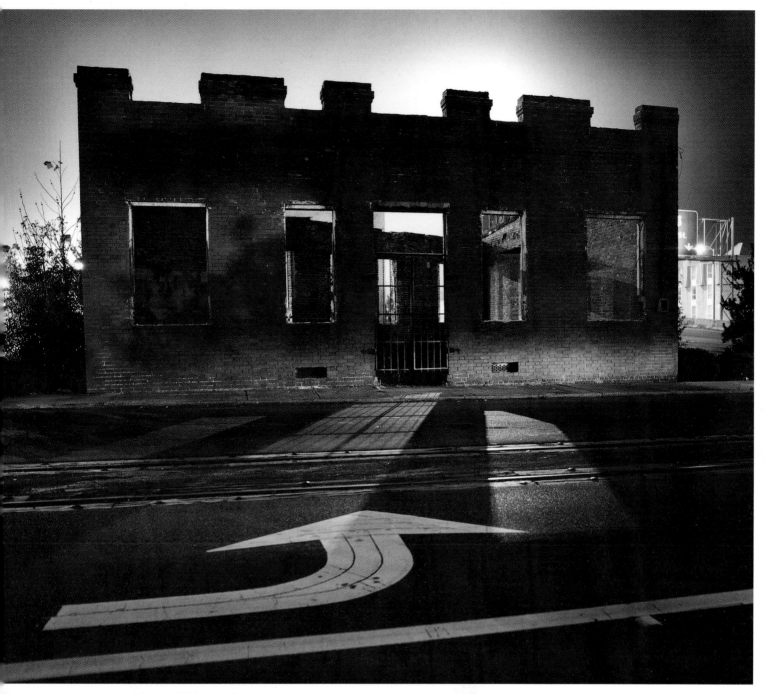

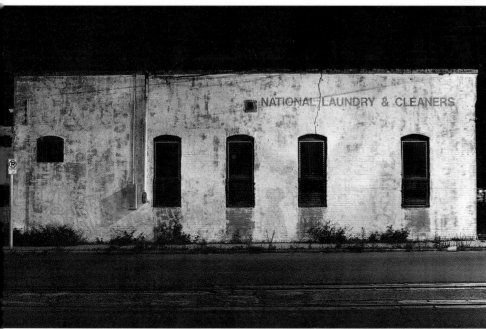

Above Above I often see a place that demands that I photograph there. This abandoned building seemed to glow inside and the missing roof added some inexplicable attraction. When I set up to shoot, I noticed the large arrow on the street pointing to the door. The interplay of elements creates a desire to know what is inside the building and what the arrow points to.

Left I was fascinated by the large crack in the stark white wall. The fact that it was a laundry seemed an appropriate juxtaposition to the building's appearance.

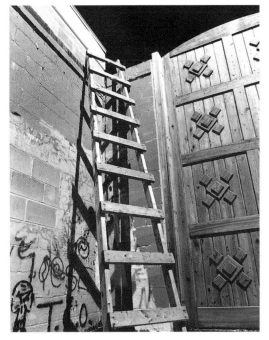

Above Stairway

This was shot on Pentax 6 x 7 55mm lens at f/11 for 1½ minutes on Ilford Delta 100. It was taken in Gainesville, Florida: The handmade ladder, so out of place and seemingly going nowhere, prompted me to shoot the scene. It is an image that is almost a cliché, but is strange and powerful enough that most viewers find something in it.

Right Home

This is the first photograph I shot at night with a 4 x 5. I had just bought the camera and went to try it out. This has become one of my favorite images. This structure is a landmark in my hometown of Pensacola, and I remember spending time there with family and seeing friends married there.

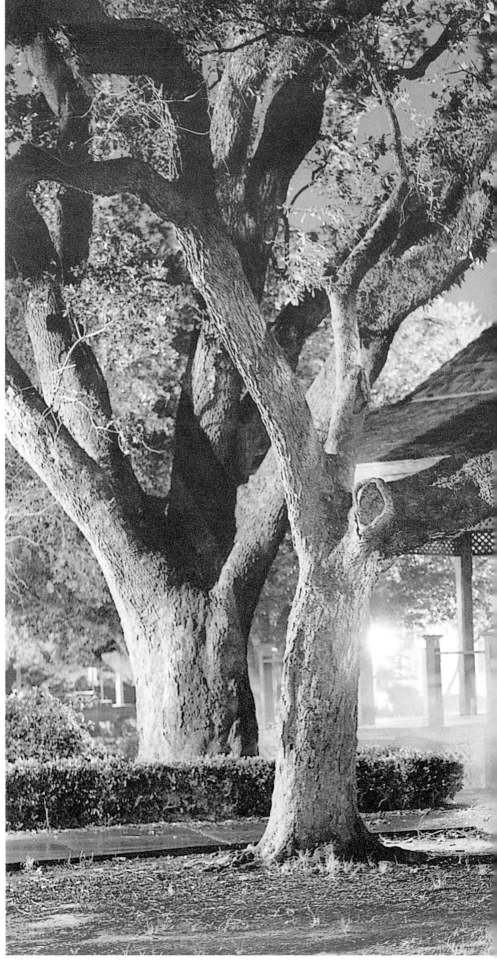

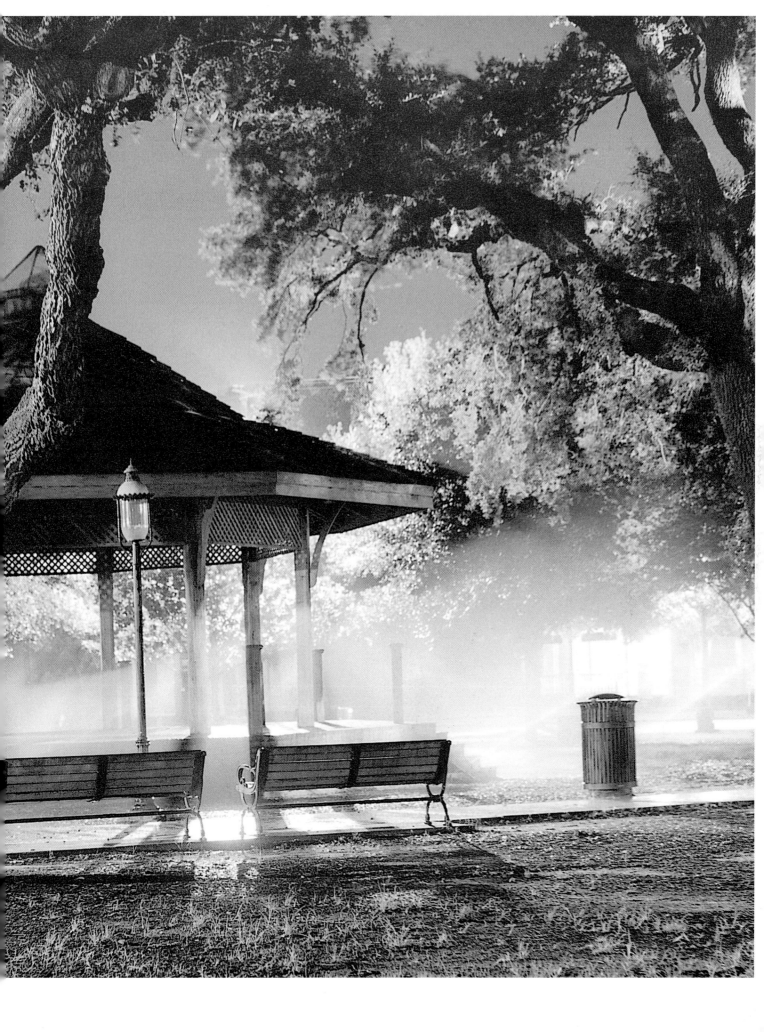

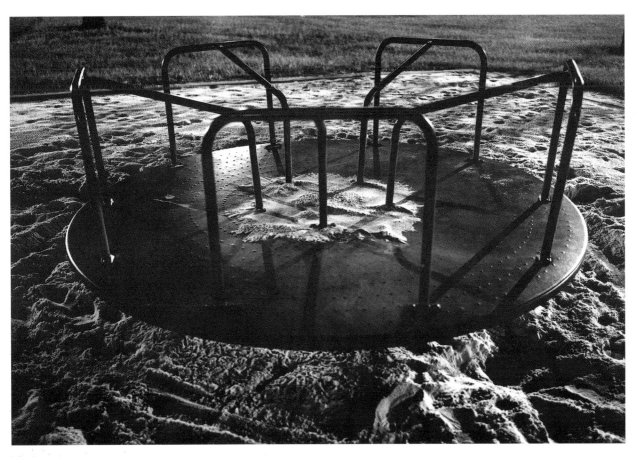

Above This merry-go-round was in a park my
girlfriend at the time used to take her son to. It was
late at night, and I couldn't sleep. The way the light
came up from underneath really blew my mind, in
real life and in the resulting photo.

Below Tents
The way the light makes this object hover,
both amazed me and instilled in me a sense of
sinister uneasiness.

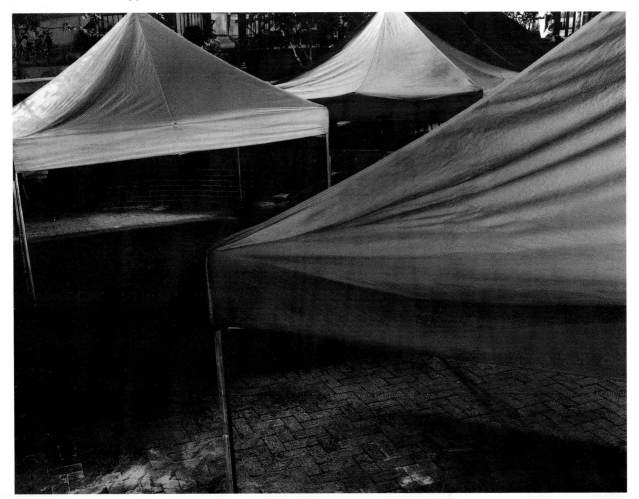

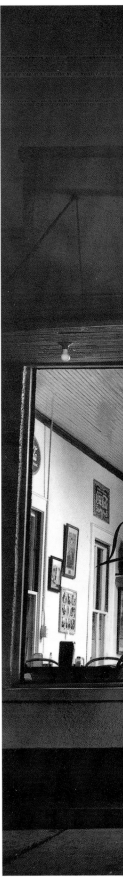

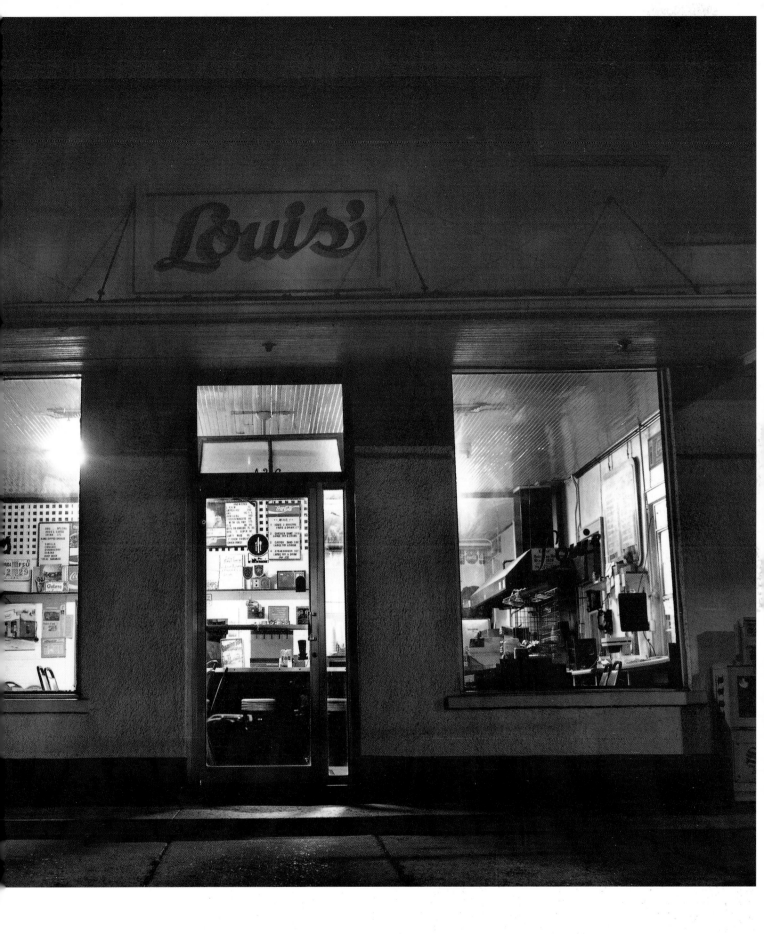

Above Louis' Diner

Everyone in Gainesville seems to have a story about this diner. I really loved the light hitting it.

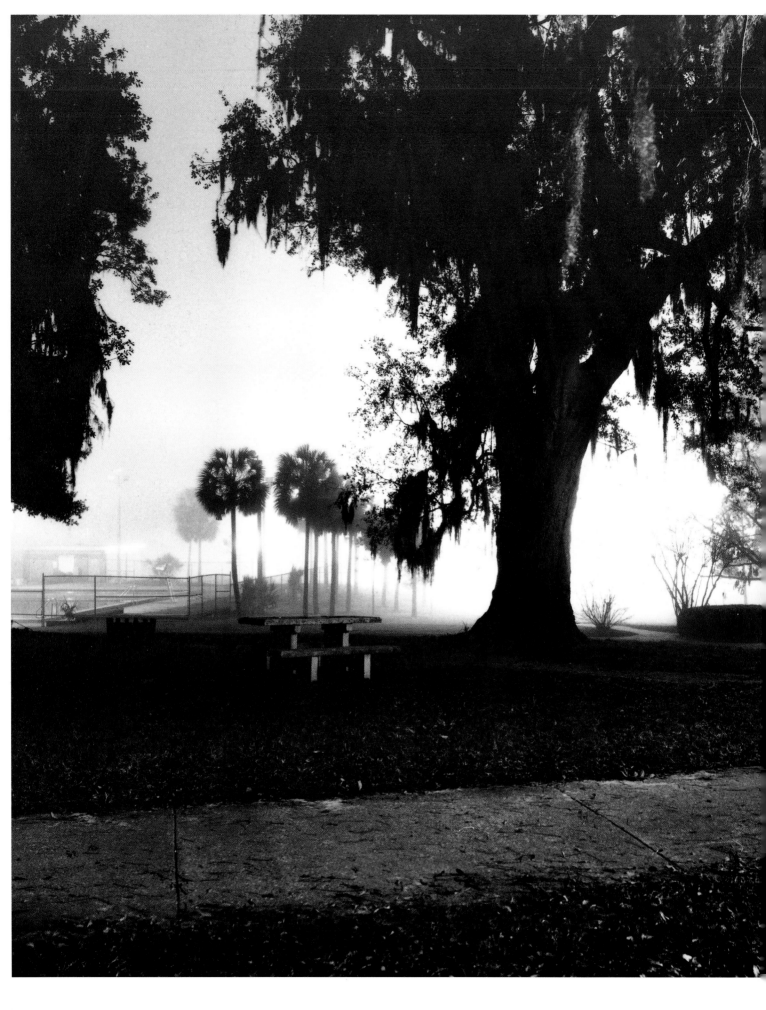

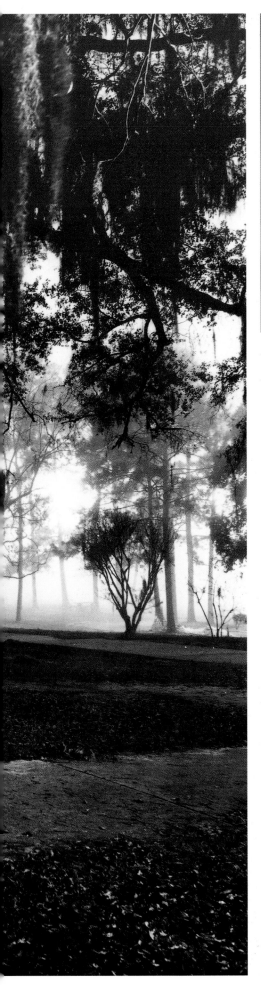

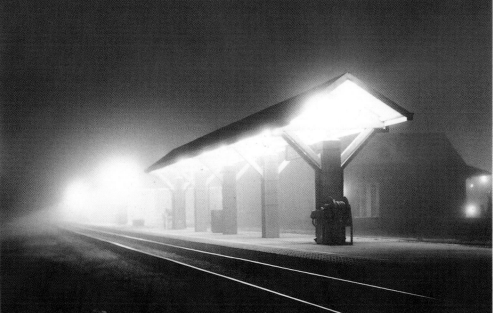

Above Pensacola has always tried to make use of trains, but it has never really worked since World War II. The depot was rebuilt in an effort to revitalize interest in rail travel, but I don't think it worked. It is beautiful though.

Left I was walking to my car from the darkroom at the University of Florida and happened to have my 4 x 5 camera, film and tripod from doing a demo on large format for a friend. The fog was incredible; it summed up everything about living in the swamp.

Above San Miguel De Allende

A group of photographers and artists stayed in Mexico for a month. I went down to hang out with them. This photograph was taken after drinking far too many margaritas outside the cantina – shot with no salt and a 4 x 5.

Right Just plain weird.

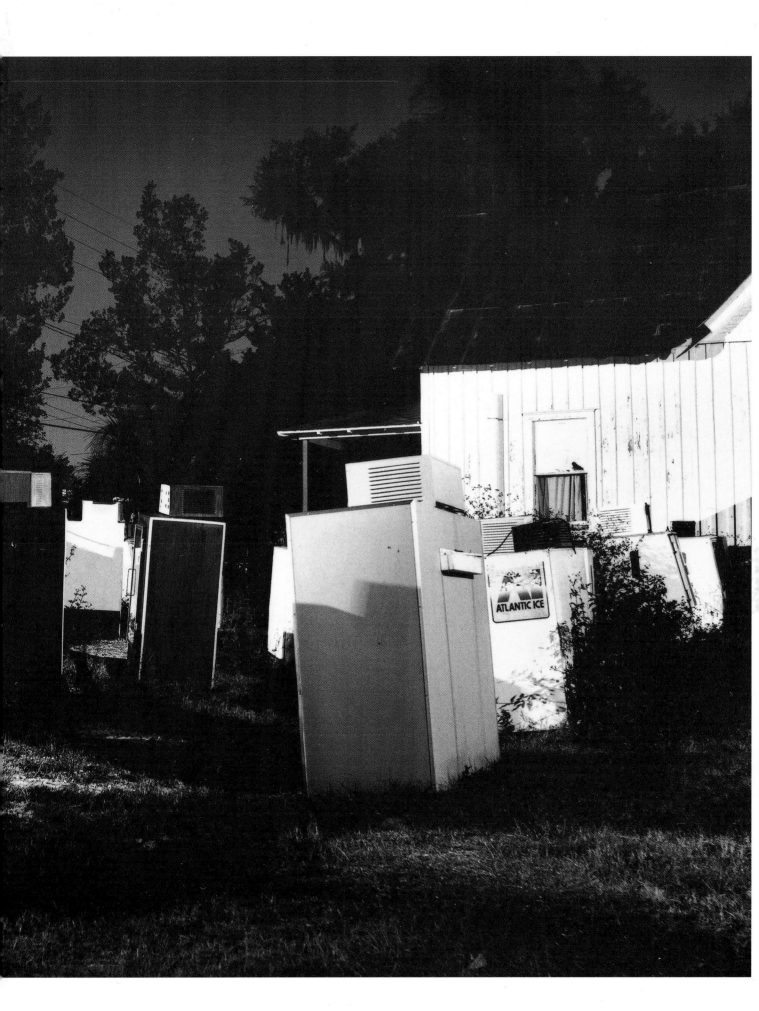

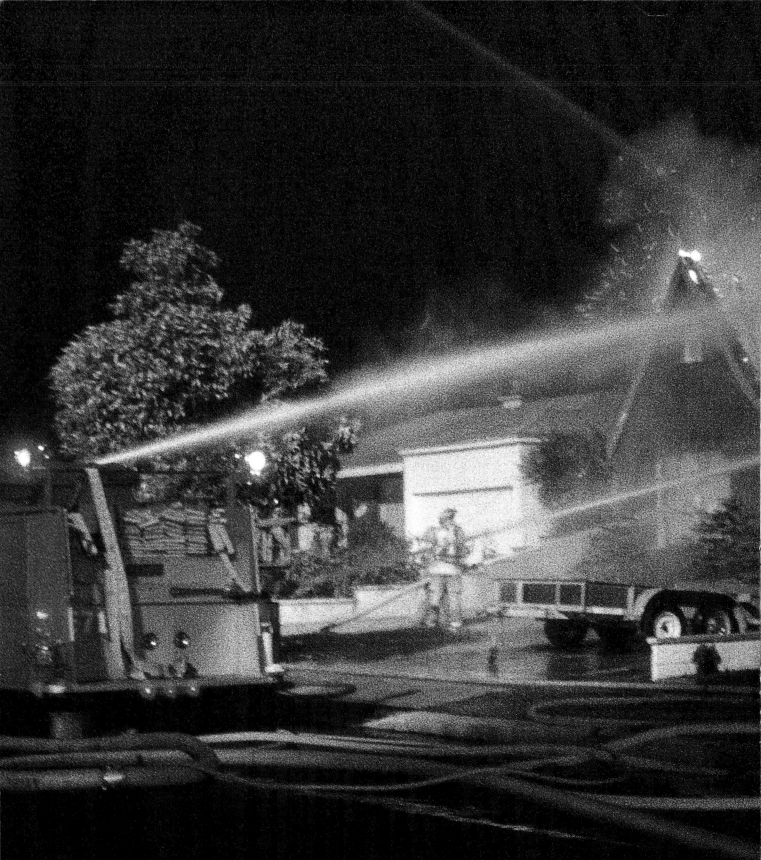

Choosing the Right Equipment

In night photography, exposures are sometimes kept to a minimum because they are so long. That makes choosing the right camera system as much a part of the finished photograph as the subject. Each format has its own advantages and drawbacks, and choosing the proper camera is a vital component of the final success of the picture.

Fire, Burbank, California
Firefighting in the day is a dangerous and dramatic event, but at night the entire scene becomes surreal, and anything that can catch or reflect light takes on new spectacular colors. It's best to work with a hand-held camera and fast color negative film, using the camera meter to average the scene.

Light Meters, Cameras and Tripods

One of the most important things that you can do is choose the proper equipment. A good way to get started on this is to know what kind of night photographs you will want to take. I was motivated by Bill Brandt, who used a large format camera, so I investigated larger cameras. Normally, you can use your standard equipment; just remember that you will need lenses that are faster (wider apertures) for night photography. If you look around in the used market you might find some of these special application lenses available for far less than new price.

Meters

For night photography a meter is the most important tool beside your camera. Traditionally, 35mm cameras have built-in meters, which are quite effective, especially on newer models, but these in-camera meters might not be sensitive enough to record very low-light situations.

I strongly suggest that anyone who wants to become involved with night and low-light photography should purchase a Luna-Pro meter made by Sekonic. In my experience, this meter will read in almost complete darkness and is very accurate.

A spot meter should always be in your camera bag because of the extreme accuracy that you can get from the reading. Remember that your meter, whether it is in your camera or held in your hand, is calibrated to read 18 percent gray (see page 50). If you intend to practice the zone system as an exposure method, a spot meter is a tool that you cannot do without.

Above Shown above are two very different types of meters. The Sekonic meter on the left is an ambient meter; the Gossen on the right is a spot meter. The ambient meter reads light more as an average; the spot reader reads very small parts of the scene, giving the photographer more control | of exposure.

Large format

For the purposes of this text, we will classify large-format cameras as 4 x 5 or 8 x 10. Using a large-format camera is more of a contemplative process than with other formats—in that you have to spend more time setting up a shot—but a very rewarding one.

Probably the greatest advantage in using a large-format camera is the image size of the film, which allows for giant enlargements without any loss of image quality. Another advantageous aspect of shooting large format is the creative control that is available by adjusting the camera—buildings can be corrected to appear straight up and down, and perspective can be brought into sharp focus by adjusting the plane of the lens or the film with various swings and tilts. This is a tremendously creative option that is not as easily achieved with other formats.

Another good aspect of using large format is the ability to use single sheets of film and control the processing of each sheet. This allows the image-maker to economize on materials. Since most of the exposures are quite long, the single-sheet option is quite valuable—and I cannot imagine using 36 exposures in a single session. Being able to process a single sheet instead of wasting an entire roll allows for complete control of the image.

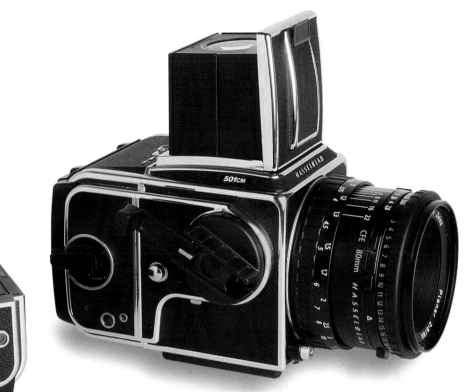

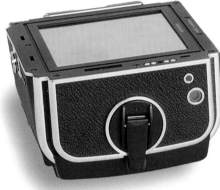

Seeing the image in a large size during the process of creation is another advantage. When the photographer views the scene through the viewfinder of a 35mm or even on the screen of a digital camera, composition is not as easy as it is when viewing the image on a ground glass.

Yet another benefit to using large format is the option of achieving myriad looks from a single-lens camera kit. Being able to extend or compress the bellows allows the photographer to explore different and unique creative options, which with different camera formats would require the purchase of additional lenses or camera attachments.

Large format does have its disadvantages, though. Film types are limited to an ISO (ASA) of 400 or under. Each sheet must be individually loaded in a completely dark room to prevent fogging. In addition, film holders are bulky to carry and must be kept dust-free.

The one single issue that seems to stop many photographers using large format is the fact that the image appears upside down on the ground glass. Some people find this extremely distracting to work with, but others love

Above A medium-format Hasselblad camera with two film backs. Using more than one back, it is easy to change from black-and-white film to color film without having to use up or waste the rest of the roll. In black-and-white photography, you may want to load different magazines with the same film so that the images can be processed differently

the fact that this characteristic helps them to isolate the composition before exposure. When I set up my camera, I view the scene to see if it fits my liking, and, more times than not, take the camera back down and look for another image. Seeing bigger images before exposure is a great help with visualization before you take any photographs.

Another practical disadvantage of a large-format camera is that it requires a very large, and thus heavy, tripod to hold it steady during exposure. Even with such a tripod, working in windy weather can produce results that might not be exactly what the photographer had in mind when the image was being made.

Medium format

Mcdium format cameras such as those made by Hasselblad, Mamiya, and Contax (also referred to as roll-film cameras), are wonderful tools for night photography. Over the years several companies have developed and sold roll-film cameras, and they can be purchased on the used market for reasonable prices.

The film selections are much greater for medium-format cameras than large-format ones, and the ability to change between film magazines allows the photographer to shoot different types of films in a single session without needing different camera bodies—you can have a film back loaded for black and white, and a different one loaded for color at the same time. The size of the negative allows for very large enlargements without loss of quality.

The more expensive medium format cameras have interchangeable lenses and a wide range of accessories that is only limited by the photographer's pocketbook. In most cases, the cameras are not electronic and allow the image-maker to work in cold conditions, or to continue to work if the batteries fail.

35mm

The single most often used camera format is 35mm. These cameras have been made since the 1920s and are readily available on both the new and used markets. In choosing a 35mm camera system for night photography, I would recommend staying with one of the major manufacturers for several reasons. These systems (Nikon, Canon, and Leica) were developed for professional photographers, and the range of accessories and lenses is vast. The used market for obtaining these brands is also much larger and normally the previous user maintains the equipment to a high standard.

Film selection for 35mm photographers is the widest available of any camera format, with new emulsions being introduced all the time. 35mm cameras require light and small tripods, and in some cases, because of the variety of emulsions available, can even be hand-held in low-light situations. This adds an extreme variety to the possibilities of composition and allows the photographer to work

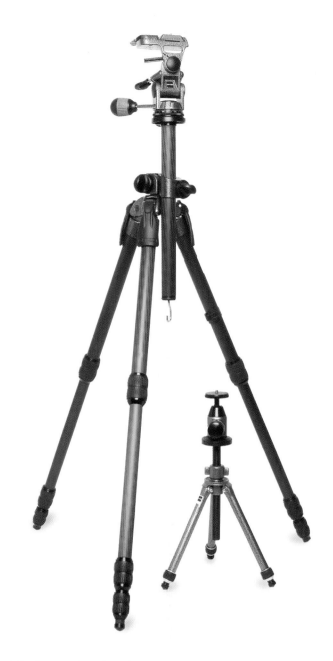

Above Tripods come in various sizes, each offering their own advantages. The larger tripods work better in windy or heavy weather conditions. Smaller lighter tripods are very easy to transport and can be used in situations where there is no room for the larger tripod.

"behind the scenes," unencumbered by large, bulky tripods, thus making many more types of images possible.

The only drawback to 35mm cameras is the small size of the negative, but even this can be used for creative effects, such as enlarged grain in bigger enlargements.

Tripod or camera support

Unless you plan to capture all of your night photographs as

documentary imagery, the most important equipment choice you can make, after meters and the type of camera format, is to have a sturdy tripod. As a standard rule of thumb, I always select a tripod that is a little more heavy-duty than the camera system requires. A cheap, wobbly tripod is a recipe for unsharp images and, therefore unsatisfactory results.

If you plan to work in windy weather conditions, a handy tripod accessory is a sandbag or a camera bag that you can hook on the center post of the tripod to give it more stability. If you plan to work from a very low vantage point, make sure that the tripod you select will allow you to adjust it so that you can place the camera close to the ground. You will also need a ball head that allows you to pan and tilt the camera, to adjust for level, or to set an angle to make the composition more interesting.

There are several well-respected manufactures of tripods—Bogen, Manfroto, and Sunpak are good-quality names with large product lines to accommodate your needs. Select your tripod carefully, and don't be afraid to have a selection if required.

Cable releases

The purpose behind a cable release is to allow you to fire the camera without jarring or jiggling it. You will need to have at least one cable release to facilitate your night photography. Make sure, when you select a cable release, that you match the release to your camera system—many new cameras require electronic releases, which can be expensive, but the camera will not operate properly without one. These releases are easy to lose, and most of them are colored black, thus making it even more possible to misplace them in the dark. Newer electronic cameras require special more expensive cable releases such as the Nikon MC-30.

Other gadgets and accessories

The items already discussed are essential for successful working techniques at night. Those that follow are additional practical items that are indispensable.

● A good flashlight. It might be wise to have a couple of these. I have a small one attached to my camera case that works on AAA batteries, so I am never without it when photographing.

● A small notebook so you can keep notes in the field and record processing instructions.

● Ultra-fine-point pens, preferably the types that can write on almost anything.

● Large plastic bags or small, heavy plastic tarps to keep dirt and weather elements off your camera during long exposures.

● A small battery-powered clock with a large face, or a lighted watch, to time exposures.

● 1-gallon plastic zip-lock bags to keep exposed film separate from non-exposed film.

Above Cable releases come in various sizes, it is always best to have an extra one as they are easily lost or bent.

The Importance of Metering

One of the foundations of night and low-light photography is learning how to use an exposure meter properly. Whether this is the meter that is installed in a camera, a handheld incident light meter, or a spot meter, it is one of the most important tools for success. There are some photographers who go out and expose film haphazardly—their success is due mostly to luck, like winning a lottery.

Capturing tones

Expressive, strong photography starts with being able to capture tones in an image. In conventional photography (where there is plenty of light, or where the photographer uses a flash system), the camera's meter is adjusted to expose for 18 percent gray (see below). In most daylight or artificial-light situations the exposure range is no more than 5 stops, whereas in night and low light photography, the contrast range can be as much as 15 stops, and is seldom much less than 10. With such an extreme contrast range to work with, you can inject creativity and choice into your photographs.

The chart below shows the standard contrast ranges for various types of films.

Type of film	Normal development	Modified development
Color transparency	3 stops	5 stops
Color negative	5–7 stops	5–7 stops
Black and white	5 stops	10 stops
Polaroid	4 stops	

18 percent gray

Exposure meters are calibrated to read whatever they "see" as 18 percent gray, or middle gray, which is a middle gray value that is used as a standard throughout the photographic industry for accurate reproduction.

A meter should be used with the understanding that the photographer knows its limits and understands how to expose with it. Without your knowledge, experience, and observation, the meter does not know the difference between a bright light or the opening of a cave—it receives those light levels as the same. It therefore becomes your responsibility to look and record the scene, and to make some creative decisions on what to include and what not to include in a composition. What should be happening here is that you are learning to place the 18 percent gray value in the final photograph.

Above 18 percent gray is the middle ground for exposure of a film or digital image. If you think of it as a bell curve, 18 percent is at the top of the curve, with the lighter or highlight tones on the right side and the lower tones or shadows on the left side of the curve.

If you are using the meter in your camera, it is also important to understand that the wider the angle of the lens the more the meter will see, and the more information it will have to interpret in order to average out the exposure. In newer 35mm cameras this is called "matrix metering." If the camera is set to the matrix mode, the meter will average the scene, including bright lights and deep shadows, to produce an "average" exposure—but no more than that.

Bracketing

One way to avoid needing to learn how to use a meter properly is to practice bracketing—taking a range of exposures from under- to overexposed, and then deciding which of the resulting shots is the best or most correct one.

A common form of bracketing is to create five exposures for each image: two stops and one stop underexposed, the metered exposure, and one stop and two stops overexposed. If you follow these bracketing steps you will get an image on film—but you will also use a lot more film and spend a lot of time on things that you will most likely throw away when you get the finished film processed.

In addition, because some of the exposures needed for night photography are very long, bracketing is not always a very practical alternative to metering. If you were to bracket a two-hour exposure, for example, you would have to do up to a four-hour exposure, and during that time you might encounter the rising sun and therefore changes in the colors of the sky and ground.

Below This store window was photographed with Fuji NPZ 800 speed film. Negative number12 was metered with a spot meter off the lights in the window, exposure 1/80 second at f/4.5; it looks just about right, but the lights are washed out. Number 13 was exposed for 1/250 second at f/4.5 and there is plenty of detail in the lighting fixtures, but everything else in the scene is underexposed. Number 14 was exposed with a spot meter for 1/25 second at f/4.5, and looks washed out, because the meter was looking into the shadows and there was way too much contrast in the scene for the film to handle. It's great to be able to see all the things in the store window, but it is unacceptable to have the great colors in the lampshades washed out.

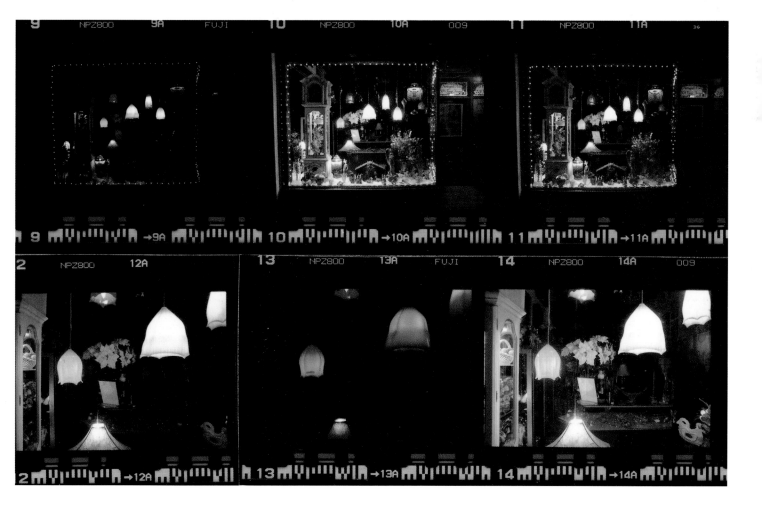

Right Here, the image was captured with Kodak E111SW transparency film. The first exposure, number 1, was made for 1/8 second at f/4.5, with the exposure set for the clock on the left side of the frame.

Number 2 was exposed for 1 second at f/4.5, with the meter set for the background; you can see how little exposure latitude transparency film has, as the lamps are completely washed out.

Number 3 was exposed for the lampshades and is almost perfect, but there is no detail or information in the rest of the image.

Number 4 was exposed with the camera set for aperture priority, using the matrix metering of the camera and metering from a gray car; the exposure was 1/4 second @ f/4.5. This image is even more washed out than when the exposure was set for the clock.

What I would consider the correct exposure of this scene is represented in number 8, and in this case it would be best to select a camera position that did not include the lampshades as such an important part of the picture. It's easy to see that the best way to capture this kind of scene would be with color negative film and a correct exposure. To obtain such an exposure, I would meter for the highlights, meter the shadows, and average them out.

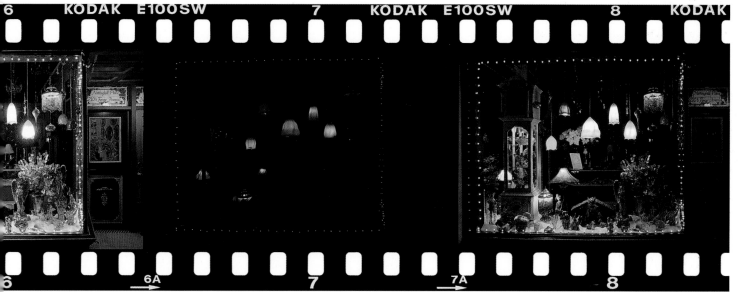

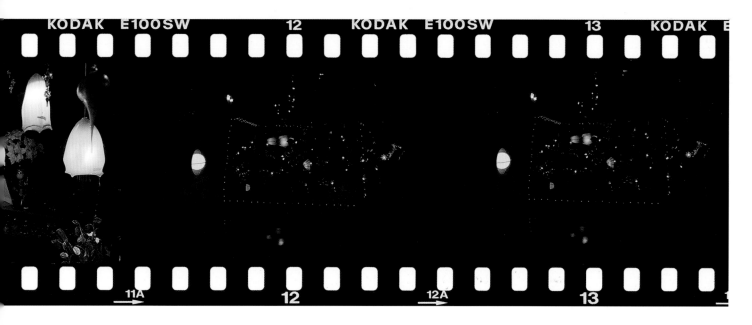

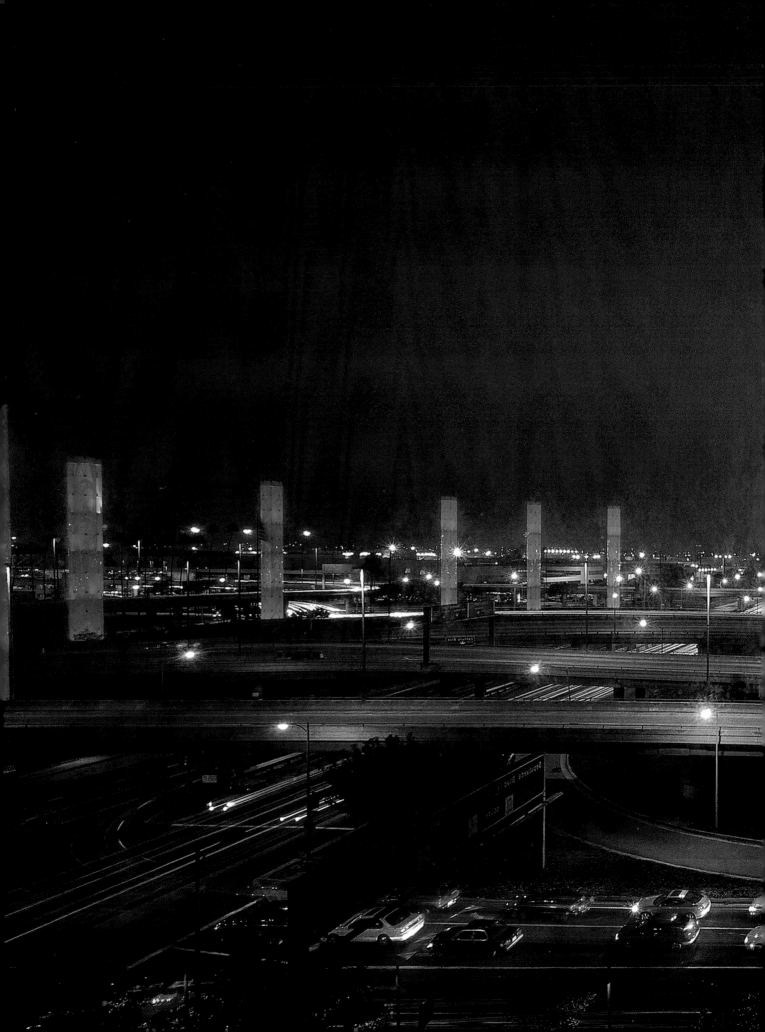

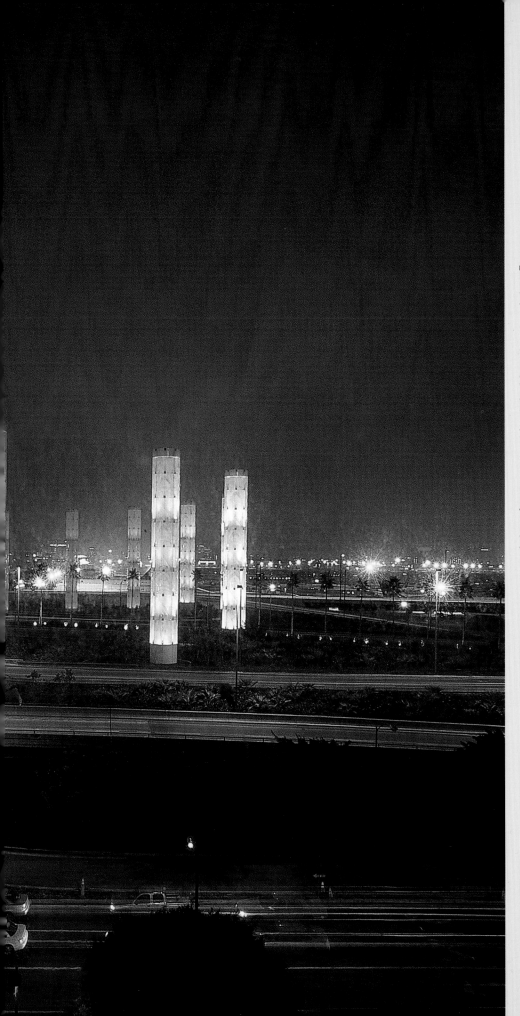

Chapter 3

Photographing at Night

This chapter looks at black-and-white films, color negative films, color transparency films, and nighttime digital capture. Each of these methods for reproducing images at night will be investigated and discussed. The various different creative possibilities and technical considerations will also be considered.

Richard Newman Los Angeles Airport. This image was made from the fifth-floor window of my hotel. I pressed the camera as close to the window glass as possible, and used the heavy blackout drapes in the room behind the camera to minimize window reflections.

Black-and-white Photography at Night

Black-and-white photography is pure magic at night. With very long exposures and proper processing, you can create illusionary imagery that will convey your ideas, emotions, and technique.

Black-and-white photography at night opens an entirely new realm of photographic possibilities to the image-maker. In color photography the colors are either right or wrong. There is only one way to develop either color transparency or color negative film—but currently there are at least 75 different black-and-white film developers available. Each film and developer combination produces a different look to the film, right or wrong stops figuring into the equation, and what becomes important is how you like the look of the result.

Photography is an abstract art form to begin with, transposing the world from three dimensions to a flat surface or two-dimensional representation. Now you have the option of introducing a lack of color, which makes black-and-white images even more abstract. Working in black and white offers the photographer new freedoms—colors don't have to be "correct," and distracting colors can be blended into the final image to complete the vision. You also have much more control over the final image, and this is even before you consider using a computer and Photoshop as an image-processing option.

Processing black and white

I recommend that you do your own black-and-white film processing. While this book does not cover setting up a darkroom, many good books and courses on this topic.

If you use a processing lab, find out what kind of chemistry and techniques they use.

In most cases, labs charge extra for special developers or changes in standard processing times, which can be very expensive and a little frustrating. However, if you are going to produce finished prints of exceptional quality, this is all part of the process.

Using filters

Before you press the shutter release, you can control the colors in the scene. Black-and-white film is sensitive to a tonal spectrum that is reproduced in corresponding shades of gray (see page 50 for how the camera and meter respond to 18 percent gray). Using color-controlling filters (red, blue, yellow, orange, green) you can eliminate or amplify colors in the scene to improve the relationships between these shades of gray.

Below A color reference chart. It's a good idea to keep this item in your camera case.

KODAK Color Control Patches ©Eastman Kodak Company, 1977

Blue Cyan Green Yellow Red Magenta White Brown Black

Above Screw-in filters like these are the easiest kind of filter to use. Ideally, you should have a red, yellow, blue, green, and orange filter in your kit. If you have several different size lenses, purchase the largest size and use step-up rings to allow the larger filters to fit on smaller sized lenses. The only drawback to screw in filters is that on very wide-angle lenses you have to make sure that the thickness of the filter does not interfere with the view of the lens and cause vignette.

The color wheel

If you are having a problem with how different filters affect film, use a color wheel. Color wheels are very easy to use and can be fundamental in understanding how filters effect black-and-white film. If you want to remove a color from the scene, use the filter that is opposite the color you want to remove (if you want to darken the blue sky, use an orange or red filter).

For a quick visual reference in the field label each one of your tripod legs a different primary color, red, yellow, and blue. Label the color that will be affected by the use of a filter on a little white tape and stick it on the opposing side of the tripod head.

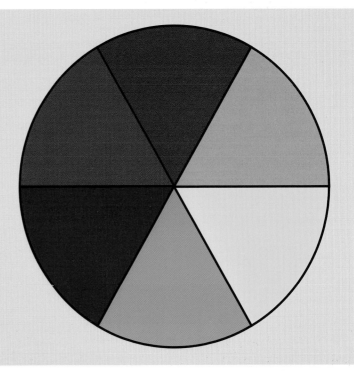

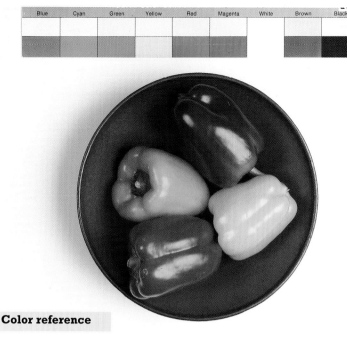

Blue	Cyan	Green	Yellow	Red	Magenta	White	Brown	Black

The examples to the right and opposite show you how different filters affect black-and-white film. In each case, the reference print has been photographed in black and white with a different color filter. It's easy to see the different results in the peppers, but the real learning can be found in looking at how the shades of the color chart have been transformed into shades of gray, and how those colors are affected by the different filter colors.

Filters for black-and-white photography permit only their own color to pass through; therefore a red filter will make a red pepper appear lighter on panchromatic film. If the pepper is photographed on a blue background, the blue will appear darker. Filters allow the primary color of the filter to build up more density on the film, while the opposite color on the color wheel will be blocked, resulting in a less exposed part of the negative, so the print appears darker.

Processing your film

In color materials the processing is either correct or incorrect; there is no middle ground, and very little modification is possible. In black and white, you have one film emulsion that can be processed "correctly" in many different developers, so where to begin is the hard part.

I strongly suggest that in the beginning you choose one or two types of films and developers, and learn to work with them until you get the results that you find pleasing.

Color reference

Above and right Use these illustrations to determine which filter would be best to use for eliminating or enhancing a color. For example, note how with a blue or red filter there is a large separation between the colors red and blue, while with a yellow filter those colors appear in almost the same tonalities in the black-and-white print. Also note that the relationships of the gray colors on the color chart appear not to be affected by any filter that is used, and that exposure compensation for each filter will be necessary. Use the examples here as a starting point only, and make sure that you test for yourself to determine total accuracy.

Black-and-white film

film	manufacturer	ISO	35mm	roll film	large format
Neopan 100 Acros	Fuji	100	x	x	
Neopan 400	Fuji	400	x	x	
Neopan 1600	Fuji	1600	x		
Agfapan APX 100 Professional	Agfa	100	x	x	x
Agfapan APX 400 Professional	Agfa	400	x	x	
Ilford Delta 3200	Ilford	3200	x	x	
Ilford Delta 400	Ilford	400	x	x	
Ilford Delta 100	Ilford	100	x	x	x
Ilford HP5+	Ilford	400	x	x	x
Ilford FP4+	Ilford	125	x	x	x
Ilford Pan 100	Ilford	400	x	x	x
Ilford Pan 400	Ilford	400	x	x	x
Bergger BPF200	Bergger	200	x	x	x
Professional P3200 T-Max	Kodak	800	x		
High Speed Infrared	Kodak		x		
Tri-X	Kodak	400	x	x	x
T-Max 400 Professional	Kodak	400	x	x	x
T-Max 100 Professional	Kodak	100	x	x	x
Plus-X	Kodak	125	x	x	x

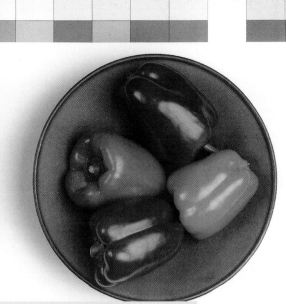

No filter. No correction.

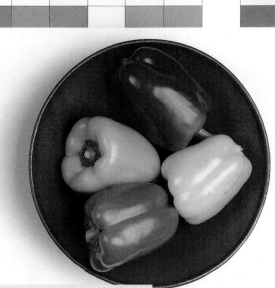

Green filter. 3 stops correction.

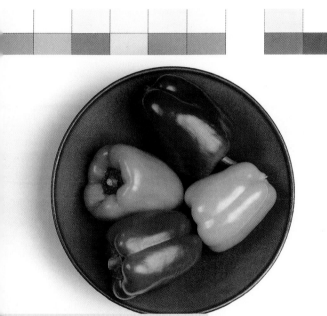

Blue filter. 3 stops correction.

Yellow filter. ½ stop correction.

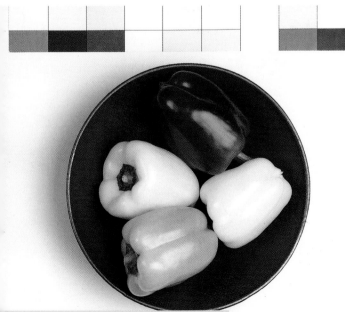

Orange filter. 1½ stops correction.

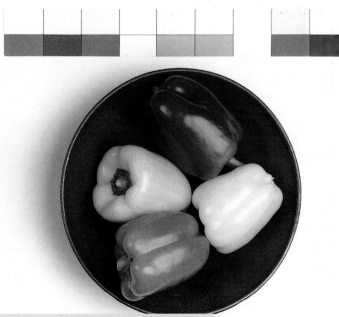

Red filter. 2½ stops correction.

Black-and-white film developers can be grouped into three separate and distinct groups:

Compensating developers These developers, such as Ilford Perceptol and Kodak HC-110, allow the user to obtain extended contrast range in the negative, making it easier to print. Compensating developers also produce prints of very fine grain. It is possible to produce negatives with as much as a 10-stop exposure range with a properly processed, compensated negative. This sounds great, since contrast is extreme in night photography. When these developers are diluted with water they produce a negative with even more range. The downside is that you will lose film speed during exposure. Test this for yourself by doing film speed tests, but in most cases if a compensating developer is to be used, you can expect your film speed to be cut in half (Tri-X would be rated at ISO 200 instead of the standard 400, and so on).

Below Both of these 8 x 10 negatives of a power-generating plant at night were processed with a compensating developer (Ilford Perceptol) for a negative speed of ISO 200. The developer for the negative on the right was diluted by one part developer to three parts water, and the one on the left was processed with no dilution of the developer.

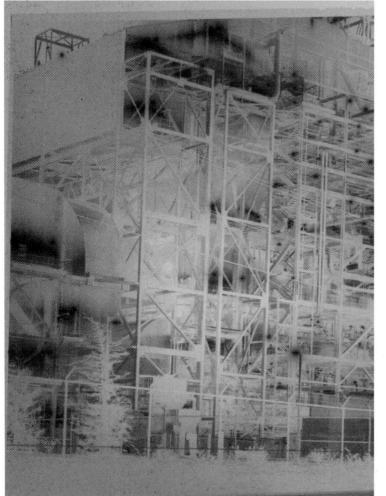
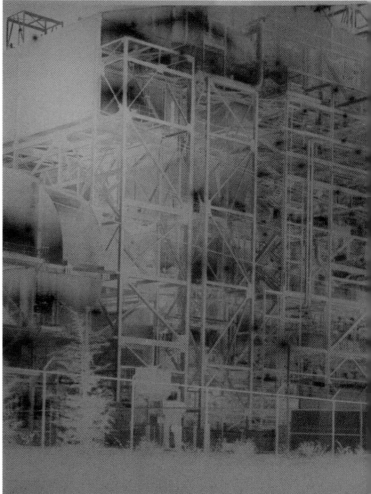

When black-and-white developer is diluted with water, the effect is very different from using it straight with no dilution. When diluted, the developer exhausts rapidly in the highlight (dense) areas of the negative, but continues to work in the shadow areas. You must also take into account the fact that when you dilute the developer you have to extend the processing times. Some of these times can get very long, but processing your film is not a race—you are going for the best results and quality. The effect on the print is one of more pleasing contrasts. In simple terms, diluting a developer helps to equalize the contrast in the negative. Study the two negatives below, and you can easily see how the diluted negative has more tones in it. As a general rule of thumb, to obtain the most detail and finest grain in black-and-white night work, use a compensating developer, but remember that for all of those advantages, you will have less film speed.

Below When you study the prints made from the negatives below, it's easy to see that the diluted developer print has much more information in it. Look into the shadows of the power plant, and at the areas where lights shine, as you can also see more detail there.

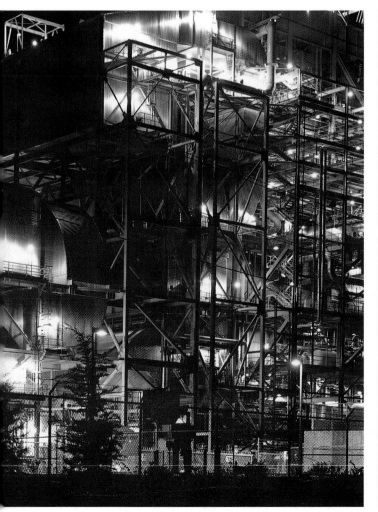
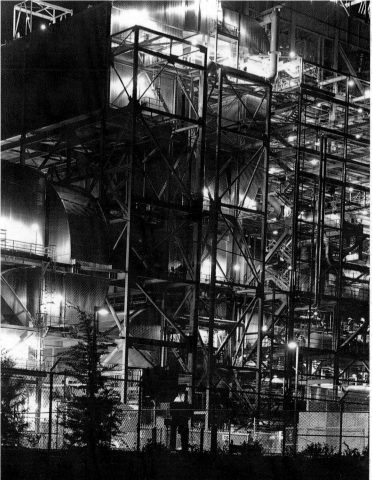

Full emulsion speed developers These developers, such as Kodak D-76 and Ilford ID-11, produce full emulsion speed from the film, meaning for example, that Tri-X should rate at 400 ISO. These are the most common developers used in labs and the developers most people start with when processing their first rolls of film at home. You can use these developers to push your processing, but better results will be obtained with the push or extended speed developers (see page 64). I recommend using full emulsion speed developers when you have exposed your film at the recommended ISO. With new emulsion technologies being produced every year, film is getting better and better all the time.

Opposite Negatives are fine, but prints are what we look at. Here, the print from Fuji Acros film that was exposed at ISO 100 and processed for 100 (top) shows a little more detail in the shadow areas (remembering contrast) than the print that was exposed at ISO 400 and processed for ISO 400 (bottom).

Below This proof sheet shows Fuji Acros film (ISO 100) exposed at ISO 100, 200, and 400 and processed accordingly, with the developing times being extended. When you extend the processing time of film, the contrast goes up. The rule here is that density on the film is determined by exposure, and contrast is determined by development. In this case, all the negatives appear to look just about the same.

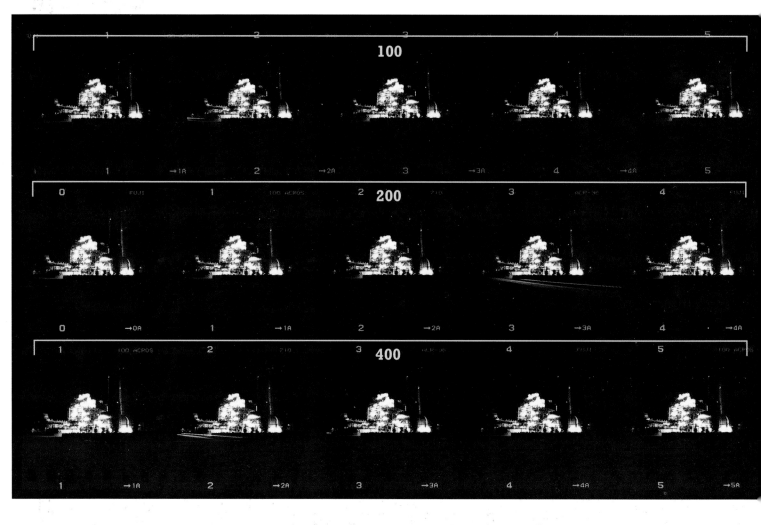

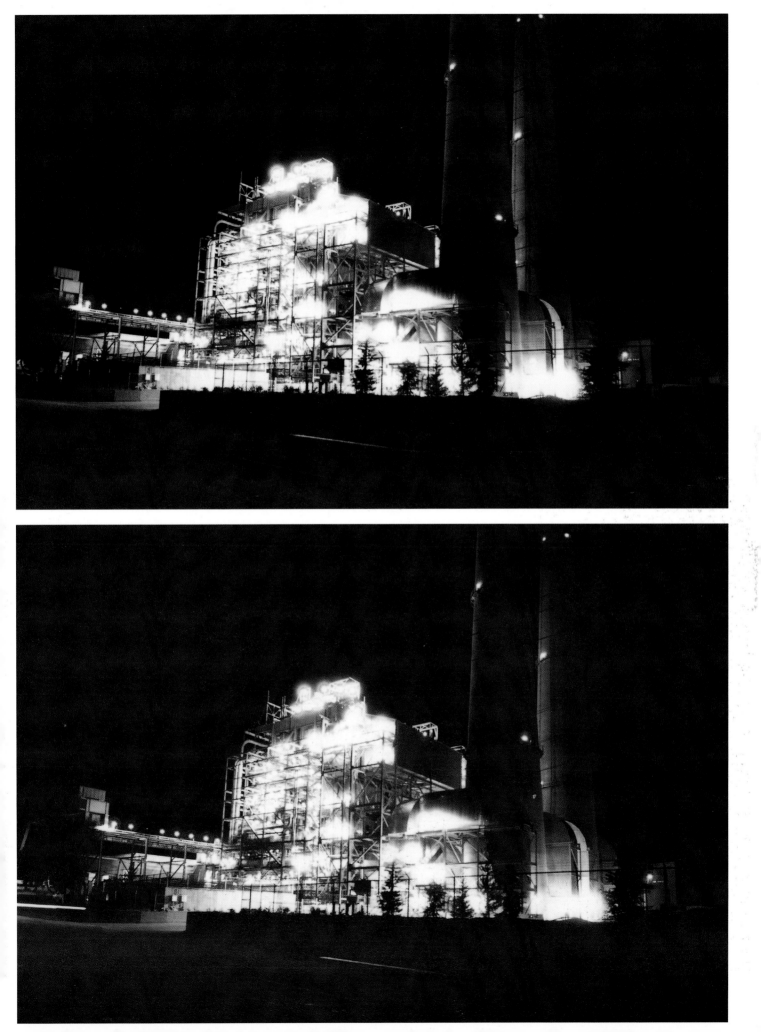

Push or extended speed developers These developers, such as Ilford Microphen, Acufine, or UFG, give the photographer the most film speed from the emulsion that has been chosen. Incredible film speeds are available, allowing photography where it has been impossible before. Two films that respond to these developers are Ilford Delta 3200 and Kodak T-Max 3200.

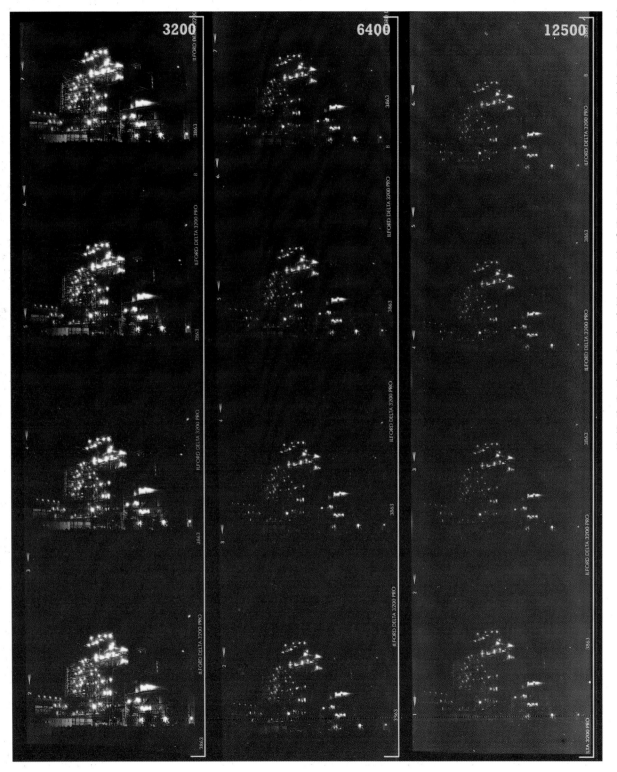

Left This proof sheet shows Ilford Delta 3200 exposed at 3200, 6400, and 12,500, and processed according to the manufacturer's recommendations. You can see from the density that the film responds very well at 3200 from the density, and that the 12,500 rating produces more grays instead of blacks. The reason for this is that when you use extended processing times the fog/over/film/base is increased. Without getting into a very heavy discussion on sensitometry here, the results speak for themselves. When you extend processing time, you increase the film's contrast and the fog/over/film/base.

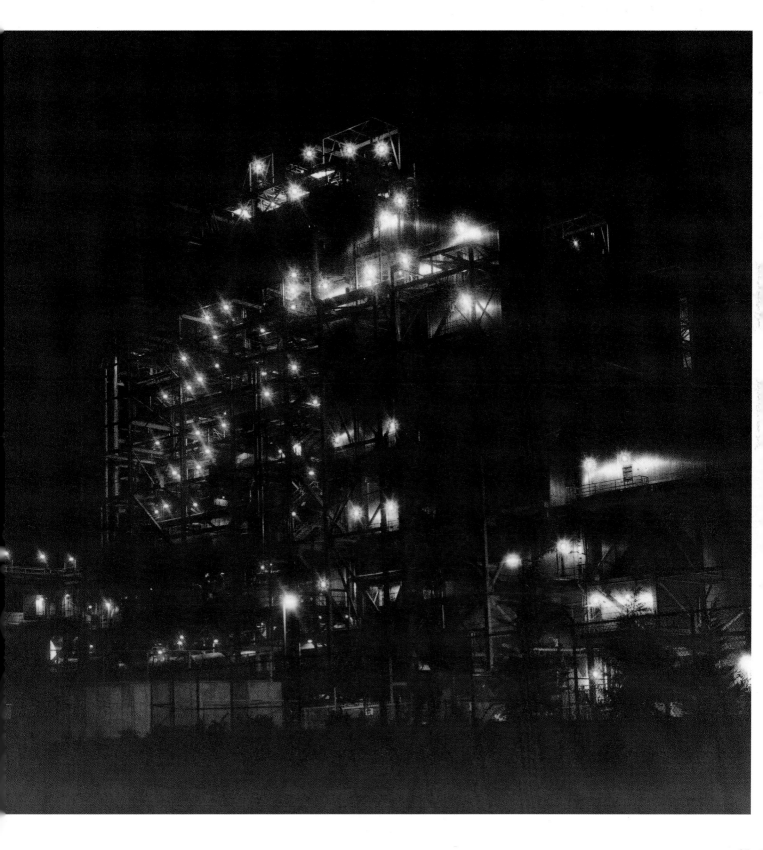

Printing your negatives

Many excellent books have been written on how to produce black-and-white prints. It's not my aim here to teach you how to make black-and-white prints, but to show you how, in the printing process, you can produce quite different looks by simply changing the contrast of the print. This is best illustrated by the examples shown below and right.

Right Both these prints were made from the same negative, taken about an hour before dawn in northern California along the Pacific Ocean and the Gualala River, with the contrast in the printing adjusted. It's easy to see the visual differences between them—the artist determines the choice of contrast, but each image displays a very different emotional impact. The line of white above the chimney, from a moving planet, in the left-hand print becomes far less visible in the right-hand one, and with some darkroom manipulation it can be eliminated during the printing process instead of having to be spotted out.

Below The initial exposure of this lawn chair was made under a full moon. You can see the greatly different effect that the low-contrast print (left) has from the others—it appears to be underexposed and looks like it was shot during the day. The last print in the middle was printed with standard contrast, and the right-hand print starts to show that the image was made at night. Note the differences in the shadows of the plants in the background.

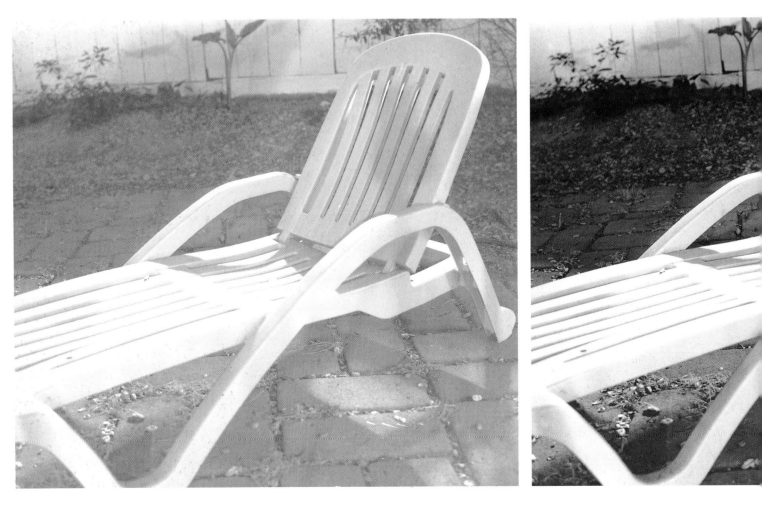

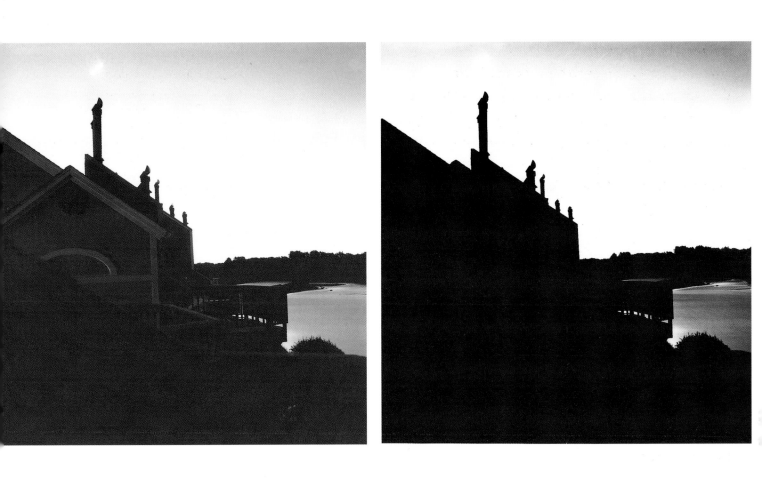

Color Transparency Film

Color transparency (slide) film used in night photography can yield some very powerful visual results. Transparency film in general has shorter exposure latitude which translates visually into images with more impact. The high contrast of night photography can use this short exposure scale to help eliminate unwanted details from a picture, and, by using proper exposure, help isolate creative elements in the image. Colors also become greatly saturated with transparency film, creating strong visual impact.

Types of film

There are two basic types of color transparency film, one that is balanced for daylight photography with a color temperature of 5500° K (Kelvin), and one that is balanced for use with tungsten-type lighting, balanced for a color temperature of 3200° K. Traditionally, daylight-balanced films are used for most photography, with external flash devices that are also balanced for 5500° K. Because there are no fixed rules in night photography, either can be used.

Reprocity failure

It is impossible to talk about color transparency film and not mention reciprocity failure. During a photographic exposure, a decrease in density occurs with certain conditions of exposure time and illuminations or light levels. This phenomenon is known as reciprocity failure, and affects the transparency's film speeds and color balance. In standard, daylight-based photography this can

be corrected by changing the exposure (usually extending it) and using corrective filters, from 05M (5 units of magenta) up to a 50B (50 units of blue). Here, what concerns us is understanding how to get correct exposure on the film. The use of corrective filters is an option that will modify the existing colors in the scene. In large-format films such as 4 x 5 and 8 x 10, manufacturers print correction filter and exposure compensation on the outside of the box as a starting reference.

Controlling the processing

Pulling and pushing a color transparency film during development is a very commonly used process. With a pull-processed film the time the film spends in the first developer is decreased, while with a push-processed film the time in the first developer is extended. A word of caution: when you push a color transparency film, the contrast will rise sharply, which can be either a problem

Colour transparency film

film	manufacturer	ISO	35mm	roll film	large format
Fujichrome Astia 100 Professional (RAP)	Fuji	100	x	x	x
Fujichrome Provia 100F Professional (RDPIII)	Fuji	100	x	x	x
Fujichrome Sensia 400 (RH)	Fuji	400	x		
Fujichrome Provia 400F Professional (RHPIII)	Fuji	400	x	x	
Agfachrome RSX II 100 Professional	Agfa	100	x	x	
Agfachrome RSX II 200 Professional	Agfa	200	x	x	
EPH1600	Kodak	1600	x		
EL	Kodak	400	x		
EPL	Kodak	400	x		
EPJ-tungsten	Kodak	320	x	x	
EIR Infrared	Kodak	200	x		
E200	Kodak	200	x	x	
EPT 160 tungsten	Kodak	160	x	x	
EPN	Kodak	100	x	x	x
EPP	Kodak	100	x	x	x
E100 SW	Kodak	100	x	x	x
E100	Kodak	100	x	x	x

or a creative technique, depending on what you are aiming for with your final image.

Exposures

Working at night with color transparency film can be very rewarding, and also quite challenging. If you are unsure of the exposure, you should bracket with a typical exposure set looking something like this:

f/5.6 at 1 minute

f/5.6 at 2 minutes (proper exposure)

f/5.6 at 4 minutes

f/5.6 at 8 minutes

f/5.6 at 16 minutes

And, for the very brave, f/5.6 at 1 hour.

Sometimes you will see some shocking results that you never would have expected. This is one of the true joys of photographing at night.

Opposite and below These four examples show what tungsten film (Fuji RTP at ISO 64) looks like exposed with an unmodified exposure. The blue cast that is built into the film emulsion is quite evident. The exposure used for these examples is exactly what the meter read. What has been done to these images is modified processing.

Images 1–4 are all exposed at the same exposure of f/8 at 1 minute. You can see in image 1 (pull-processed by 1 stop) that the image looks underexposed. Image 2 also looks (and is) underexposed; the processing is normal. Image 3 has the same exposure but has been pushed 1 stop; the image is starting to appear.

Image 4, even though 1 stop underexposed, is pushed 2 stops in the processing and appears to have enough information. Push-processing is a great fix for films that have been underexposed, but where you still want to use (and can't duplicate) the image you created.

Above These four examples show what daylight film (Fuji RDPIII at ISO 100) looks like exposed with an unmodified exposure. The general overall cast of this film is much warmer. The exposure used for these examples is exactly what the meter read. What has been done to these images is modified processing. Images 1–4 are all exposed at the same exposure of f/8 at 1 minute. You can see in image 1 (pull-processed by 1 stop) that the image looks underexposed. Image 2 also looks (and is) underexposed; the processing is normal. Image 3 has the same exposure but has been pushed 1 stop; the image is starting to appear. Image 4, even though 1 stop underexposed, is pushed 2 stops in the processing and appears to have enough information. Push-processing is a great fix for films that have been underexposed, but where you still want to (and can't duplicate) use the image you created.

Below These three images are a visual description of how reciprocity affects exposure. The film used is Fuji RDPIII Professional with an ISO of 100. Images 1 and 2 were exposed at what normally would produce similar looking exposures, image 1 being exposed at f/8 at 2 minutes and image 2 being exposed at f/5.6 at 1 minute. Image 3 was exposed at f/5.6 at 4 minutes. In normal daylight photography you would expect image 3 to have 4 times the exposure, but were we to want an image with 4 times the exposure, I would expect the initial exposure time to be 32 minutes.

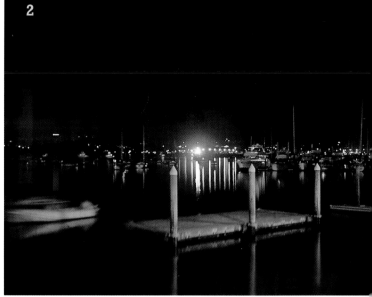

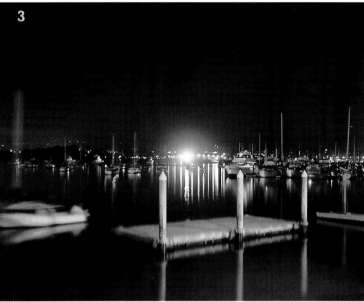

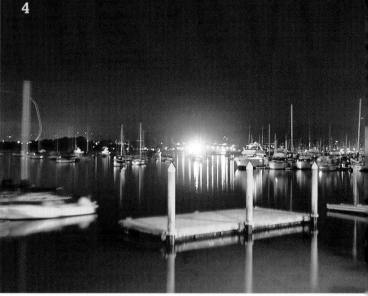

Above These four examples were all made with the same compensated exposure of f/8 at 2 minutes. This is the correct exposure for this scene. What you can see from the altered push-and-pull processing applied to the film is how the contrast of the scene goes up, along with the detail recorded. This harbor scene in Monterey, California, is in the flight path for the local regional airport. Note the appearance of a helicopter in image 2, and a plane in image 4.

Right Rita's Ice, Salisbury, Maryland
I love the richness of the Volkswagen Beetle and the colors reflecting off the black paint of the car. The white wall has texture in it, which is a good sign when judging whether your image is successfully exposed: keeping detail in the whites and not overexposing them.

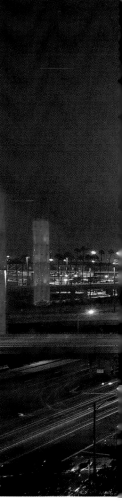

Above These images were recorded at a local carnival. A camera support (a handy post) was used for the spinning lights to obtain maximum sharpness, and a tripod for "Flying Bobs".

Right As you land at Los Angeles International Airport you are welcomed by these "light sculptures." I photographed them through my hotel room window; if you look closely, you can see the reflection on the glass. I made a tent around the camera with the hotel blackout curtains and tried to shield as much reflection as possible, which was barely noticeable during the exposures.

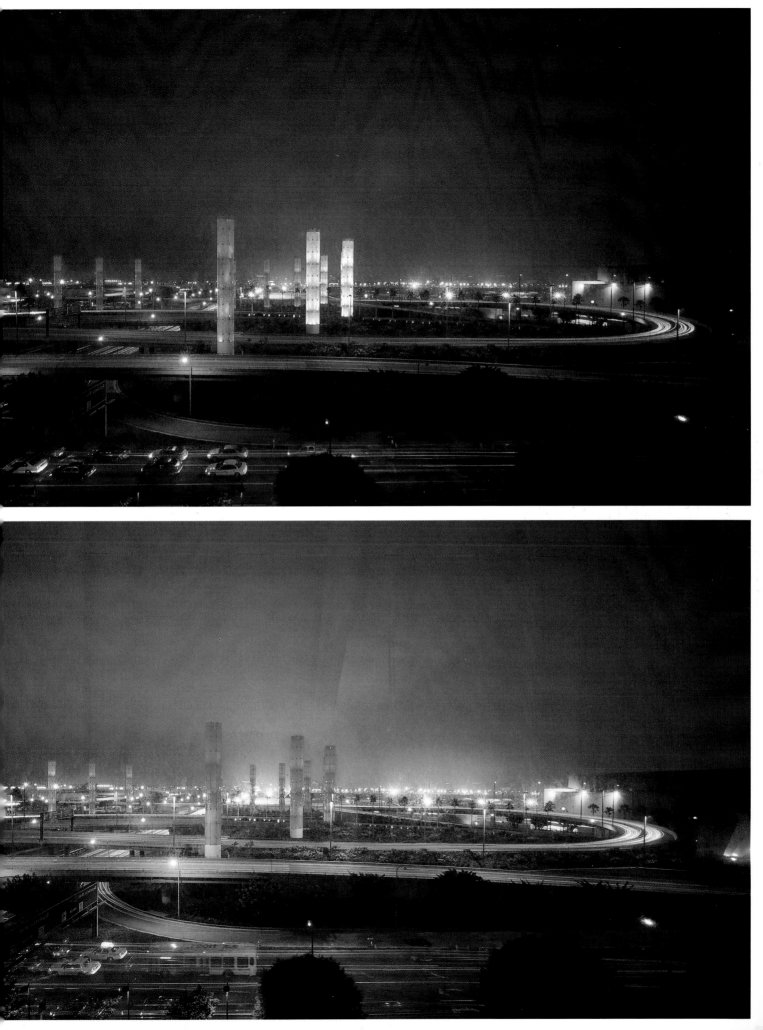

Color Negative Film

If there were one film and method that would guarantee success in night photography, it would be color negative materials. Over the past five years, manufacturers such as Kodak and Fuji have spent huge sums of money and research time on perfecting color negative materials.

In the past, if you were a professional photographer, and given an assignment, (except photographing weddings), you exposed your work on color transparency film. With the amazing new films out there and developments in processing technology, color negative material is an accepted tool. We now have color negative films with an ISO of 800 that look like the ISO 200 speed films of five years ago, only with better color saturation and finer grain.

Although there is no easier way to achieve success with night photography than to use color negative film, if you take your images to a regular lab and expect to see the results of bracketing or exposure modification, you will be disappointed. For accurate results and to see the outcome of your efforts, take your unexposed film to a professional color negative lab and request a proof sheet.

Processing

Color negative film is completely different from color transparency and black-and-white film in that nothing can be done in the processing stage to modify the outcome of the negatives. The processing is done either correctly or incorrectly, and, most of the time, incorrect processing is the result of shoddy workmanship from the lab. Most problems stem from not changing the chemistry at the prescribed time. I use a local one-hour lab and get wonderful results. Every color negative film has a profile that can be loaded into the one-hour machine for optimum results from that negative base—the orange color you see when you look at the negatives.

Printing

When you want to print your night work from a color negative you have two real options. One is to find a custom color lab and have the prints made there. The lab will have a choice of different contrast of paper, from soft contrast to hard contrast. One-hour labs use a variety of medium-contrast papers. Requesting different contrasts on your color prints will require a great relationship with your lab and a very fat pocketbook, as all of these prints will be billed on a custom-charge basis.

When you get your prints back from the lab, some will appear perfect and others very grainy and lacking contrast. About 99 percent of the time, the reason for this is either very bad exposure improperly functioning batteries that need to be replaced. I use rechargeable batteries in my camera, but always keep an extra set, just in case.

Your second option for printing from a color negative is to use your scanner to scan color prints and make digital files from them. However, a better option is to scan your color negatives and then work with the digital files to create color prints on your computer. There are a million different opinions on how best to scan a color negative, and dozens of books have been written on this subject alone; what is offered here is a starting point to work from.

Equipment for scanning color negatives

Scanning color negatives can be frustrating without the appropriate equipment. Any sort of digital image manipulation is very memory-intensive for any computer. If your computer is over five years old, digital image processing may be difficult to perform on your system; it may be worth a complete computer upgrade. Computer speed is not as essential as RAM (random access memory) or chip memory. Purchase as much chip memory as you can afford. Your computer should have a minimum of 128 MB (megabytes) of RAM, and the more

Colour negative film

film	manufacturer	ISO	35mm	roll film	large format
Fujicolor Superia X-TRA 400	Fuji	400	x		
Fujicolor Superia X-TRA 80	Fuji	800	x		
Fujicolor Portrait NPH 400 Professional	Fuji	400	x	x	
Fujicolor Portrait NPZ 800 Professional	Fuji	800	x	x	
Fujicolor Press 400	Fuji	400	x		
Fujicolor Press 800	Fuji	800	x		
Fujicolor Press 1600	Fuji	1600	x		
Agfa Optima 100 Professional	Agfa	100	x	x	
Agfa Optima 200 Professional	Agfa	200	x	x	
Agfa Optima 400 Professional	Agfa	400	x	x	
Portra 800	Kodak	800	x	x	
Portra 400NC	Kodak	400	x	x	x
Portra 400VC	Kodak	400	x	x	
Portra 160 VC	Kodak	160	x	x	x
Portra 160 NC	Kodak	160	x	x	x
Portra 100T tungsten	Kodak	100	x	x	x
GC	Kodak	400	x		
GB	Kodak	200	x		
GA	Kodak	100	x		

the better. Fortunately, computer memory chips are fairly inexpensive and easy to install. If you have decided you need more memory and have doubts that you can install it properly, go to your nearest computer store or service center for help.

Another consideration is hard disk size, and whether or not you have a back-up device for writing large files, such as a writeable CD-ROM, DVD, or Zip drive, and/or large amounts of hard disk space. If digital photography is the format in which you wish to work, an internal drive of 20 GB (gigabytes), an external hard drive of at least another 20 GB, and a writeable CD-ROM work well together. Edited images can become very large in file size, and quickly consume hard drive space. With a large, external hard drive, you have the space to work on your images, and the CD-ROM or DVD allow you to permanently archive the finished images without taking up hard disk space.

Major improvements in scanner technology take place every year, and good-quality flatbed scanners are quite affordable. I use Epson scanners and printers with my Apple G4. For a relatively small amount, you can purchase a scanner that will scan up to 4800 dpi (dots per inch), with good color depth. (The more color depth you have, the greater the number of colors that are represented in the image.) For scanning negatives you need a scanner that can scan at minimum 1600 dpi, as that will allow you to scan a 35mm frame and enlarge it for printing at 4 x 6 inches without a great loss of picture quality. Many scanners also have a transparency attachment that shines light through a negative or color slide while scanning, allowing the image to be captured with better color. Scanners with transparency units also have special software that simplifies scanning and color, correcting color negatives.

Armed with a decent computer and scanner, the final part of your adventure in digital photography involves good software for image enhancement, particularly if you wish to try color correction. I use Adobe Photoshop, which is the industry standard. Other graphics programs do exist however, and may provide you with everything you need—PaintShop Pro is a good alternative program. Look for programs that will let you resize, save in multiple file formats (tiff, jpeg, etc.), work in layers, and have histogram and curve controls.

File formats

Understanding file formats will help your digital photography. A file's size, in megabytes, is a function of color depth, image size (length and width), and resolution.

You have the option of saving your pictures with a graphics software package, usually in many formats. Always try to save your digital pictures for archiving in the least compressed format, such as TIFF (Tagged Image File Format), or EPS (Encapsulated PostScript). Other file formats can save disk space, but may not look optimal because of data loss.

Good compressed formats to use, in order of best image quality, are PNG (portable network graphic), JPEG (Joint Photographic Experts group), and GIF (graphics interchange format). Once you save your scanned TIFF, you can then save it in a more compressed format from that file. If you first save compressed, such as JPEG, you cannot save as an uncompressed TIFF and expect to retrieve your file quality, so always first save as a TIFF or EPS.

JPEG and GIF are by far the most common compressed image formats. You might want to use a compressed format file for a website, or for e-mailing. A good rule of thumb regarding e-mailing images is to never e-mail a picture greater than 500 KB (kilobytes). There are many other formats, but these are usable on any computer platform.

Scanning color negatives

Color negative film has an orange base color when developed. The orange base differs between manufacturers and types of film, so you need to calibrate your scanning for each type and manufacturer you are using.

If your scanner software does not have a "color negative" setting, use this basic method for scanning a 35mm color negative. Scan your negative with at least 1600 dpi and at least 24-bit color depth, cropping it in the pre-scan to the size of the negative strip. If you do not crop it, you will end up with a very large file! Save this as a TIFF file.

Open this file in Photoshop, and add a layer, changing "Normal" to "Color" **(see 1 above)**. Using the color

picker, select a piece of orange base. A good place to do this is on the frame of the negative where the film numbers are located. Under Edit, fill the foreground of this new layer with the orange color at 50 percent opacity **(see 2 above)**.

Once filled, invert the color. Merge the layers so your negative now looks slightly blue. Under Adjust, you will find a number of tools you can use to pull out the colors in the neutralized negative **(see 3 above)**.

Histograms are a good place to start, looking at red, green, and blue channels to search for an even distribution of "signal." Curves can be adjusted, setting a slight "s" pattern in each red, green, and blue channel. You can also try adjusting where you select the orange color, the opacity (the amount of orange color neutralized). Getting truly good results means knowing the software—what does each control do, and what does each negative need? When the adjustments have been made to the negative, invert the color to produce the positive image **(see 4 above)**.

Alternatives

It is far easier to see the results of taking a picture with color film by scanning the negative with a transparency unit on a scanner using the color negative software that comes with the scanner. The results are surprisingly good, and you can quickly see differences in different exposures. If you cannot afford a scanner that is dedicated to negatives and transparencies only, a flatbed scanner with this option is a good affordable alternative.

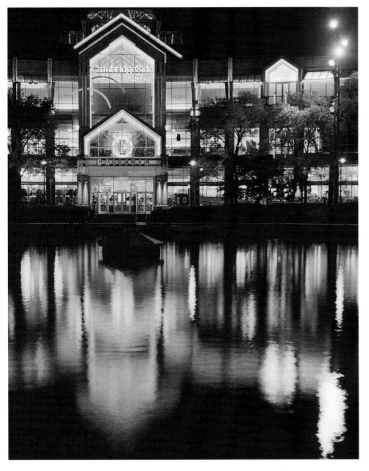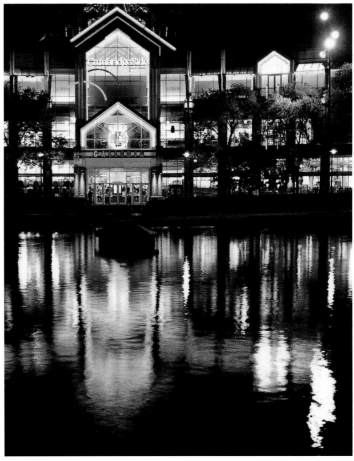

Above This image was photographed on a tripod with color negative film. In the version on the right, the colors could not be richer, and the combination of the lights from the shopping center and the reflection on the water makes a beautiful image. The shot on the left, taken under the same conditions and using the same film and equipment, has been slightly overexposed, leaving the colors paler and less vibrant.

Below Because of tremendous technology advances in the past several years distinguishing the correct exposure when comparing final prints can be deceptive. The print on the left was exposed at the recommended setting, and the one on the right was exposed 3 stops less. The differences in the prints are very hard to see without very close examination.

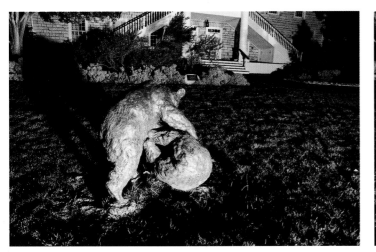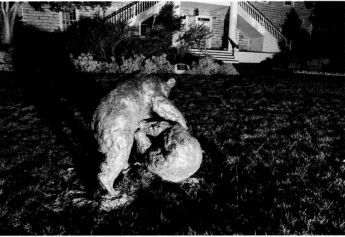

Digital Photography

Digital photography is a new and expanding field that allows you to check your composition and exposure—if you can judge from a 2-inch screen. It allows you to take exposures (or files, as we will refer to them) and modify them later in the computer without having to go to the lab for film processing. It's a wonderful tool in the very early stages of development.

Digital cameras

Let's get started by selecting digital cameras for night photography, although it feels slightly foolish to write anything about this because the technology is changing so rapidly that it's difficult to keep in touch with the most current trends and changes.

There are two basic types of digital cameras—one works with single exposures, the other like a scanner, except it is in the film plane instead of traditional film. Scanning cameras are very expensive and capable of creating very large file sizes. For the purposes of this discussion, we will focus on the CCD (charge-coupled device) and CMOS (complementary metal oxide semiconductor) type of cameras.

Make sure when you go looking for a digital camera that it is capable of saving in a file size that is at least 3 mega-pixels. This will allow you to create 8 x 10 images without too much of a "digital look." Also, try to find a camera that allows you to use it in a manual mode—digital photography was not made to work in very low light or night situations, so you have to fool or trick the camera in order to get exciting, expressive exposures.

Left Here, the exposure is very good, but the image does not give the viewer the feel of a dark and sacred place.

Right This example of Father Sierra's crypt is the exposure that the camera wanted to see. You can see how it's a washed-out and very average photograph.

Right In this example, the camera was used on manual mode and the exposure was set 2 stops over. You can see the emotion in the statue's face, and the feeling is one of quiet commitment.

How a digital camera works

The function of a lens on a camera is to focus light on a plane. In a film-based camera, that plane is covered by light-sensitive film. In a digital camera, however, that plane is covered with light-sensitive solid-state semiconductors called photo sites. There are two types of semiconductors, CCD, and CMOS. Technology for CMOS has been around for some time and is cheaper to produce, but does not have the resolution yet of CCD technology, which, at the time of writing, has more pixels and therefore more quality.

CCD is an array of light-sensitive semiconductors that convert light energy into electrical energy. The more light that is present, the greater the electrical charge. The color image light energy enters the lens, and then encounters color filtering that filters the light energy into its color components of red, green, and blue as it hits the photo sites. Filtering the light entering the photo sites can have one of many mathematical patterns; it is difficult to say which pattern might be better than another. Simply, one method of filtering might employ three photo sites, one filtered red, one green, and one blue per pixel. For most cameras, though, a deliberate pattern of filters over the photo sites is more economical and yields good results.

Patterns of filters are created based on how the human eye perceives color. We are most sensitive to the changes in the green spectrum. One commonly used filter system, the Bayer pattern (named after the Kodak engineer who invented it), utilizes this sensitivity to green in its filter array by including more green in its array of red, green, and blue. Most digital cameras use this filter system. The filter also limits higher frequency light energy (infrared), but some cameras have an option for infrared filtering. Digital cameras may also be less sensitive to lower frequency light (blue end of the spectrum).

The filtered electrical charges are moved off the sensor plane as analog information. The computer of the camera now changes that information to digital format, and processes the image, interpolating the color of each pixel in the image. The image is written to a digital file, and stored on a memory card, such as Compact Flash, Memory Stick, Smart Media, or PC. The file can then be downloaded to a computer for printing.

Most cameras capture this single image instantaneously as a film camera would, but there are very high resolution cameras that have what is termed a scanning film back. Scanning backs are typically used on view cameras, and the sensors work in a way similar to a flatbed scanner. The CCD sensors are mounted on a plane that moves slowly across the film plane of the camera. This type of scanning back is not good for subjects that move, but is invaluable for studio shots of products or still life. Scanning back cameras are also very expensive, but produce the highest resolution possible for a digital camera.

Using a digital camera at night

In the first place, remember that we are working with a capture method that is brand new and ever-changing. The "film speeds" on digital cameras relate to what we have known in the past. Set your camera up for the highest ISO that the camera can produce.

With film, when you change to a higher ISO film with the new emulsion technology, the grain is still very small. With a digital camera, however, when you select, for example, the ISO 320 setting you are increasing the digital noise, which makes the images look very grainy.

Above The menu screen of a digital camera. You will make all of your ISO and file size adjustments on this screen.

Above This photograph was made with the white balance in the camera set for 3000°K, and the exposure was 8 seconds at f/6.3. The airplane was a bonus as it crossed the Charles River, heading for landing at Boston's Logan Airport. This white balance setting is very close to what tungsten film would look like, except that the airplane would have been captured very differently.

Above In this picture, the white balance was set for 7500°K. The exposure was again 8 seconds at f/6.3. The entire mood of the image is different and warmer.

Above This picture was made with the digital capture of a lighted boat parade. The image is rather lifeless, as I was trying to capture the movement and the colors from the boats.

Above Using traditional film gave the image life and movement. In some cases, digital is absolutely the right tool for the job, and in others traditional film is the answer.

Changing balance

One exciting thing that you can do with digital photography is change or adjust the "white" balance on the camera to alter the color of the scene. In traditional photography, the choices would be to use tungsten or daylight film and then filter it from there to obtain different color balances. In the case of better digital cameras, you can adjust the white balance before making the image.

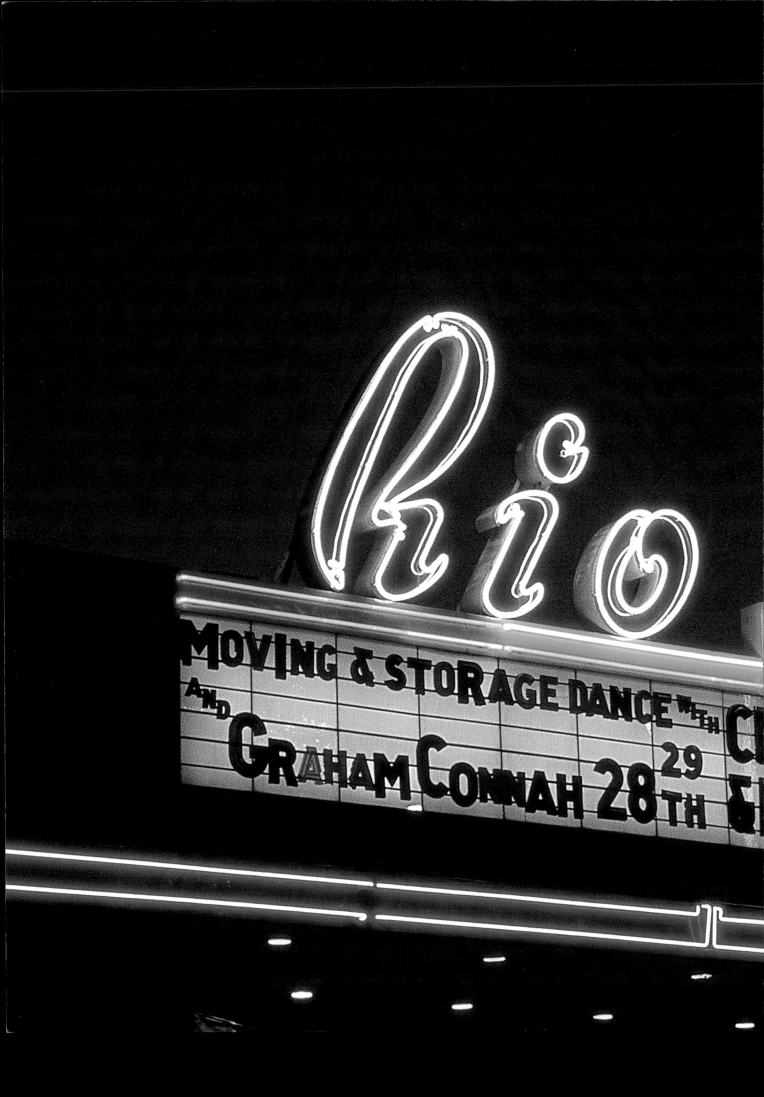

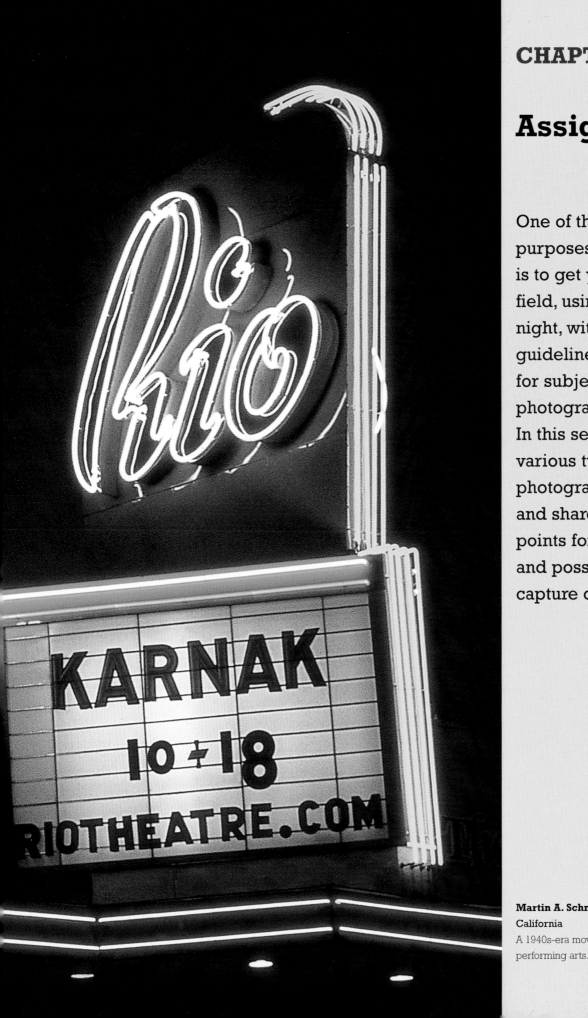

CHAPTER 4

Assignments

One of the main purposes of this book is to get you out into the field, using a camera at night, with some guidelines and ideas for subjects or topics to photograph at night. In this section we look at various types of night photographic situations, and share starting points for exposures and possible film or capture options.

Martin A. Schmidt Rio Theater, Santa Cruz California
A 1940s-era movie house that is now used for live performing arts.

Street Photography

Street photography or reportage-type imaging is exciting, especially at night. Lights reflect off wet streets, and dramatic compositions are possible with the simplest of subjects.

Aim of Assignment

To be very aware of all that is going on around you, and to be prepared to record the image instantly when it is ready in front of you.

Equipment

- 35mm camera
- color negative and high-speed black-and-white film
- 24–28mm or 35mm lens
- cable release

What to Do

Work in aperture-priority mode in the street at night, which gives you good depth of field. An f/1.4 lens will give you tremendous options, even if it is your only lens. If you are using black-and-white film, make sure that you use the highest possible film speed, and try not to use push-processing, since the contrast in the negative will be almost unprintable. Use the highest ISO film possible, and use compensating developer, even though you may lose some film speed —it's very important that you have as much information in the negative as possible to make the best possible print later in the darkroom. Always keep a pad of model-release forms in case of publication later. A tripod will only slow you down in the street and could get you run over, though a cable release is great for sneak shots where you do not put the camera up to your eye.

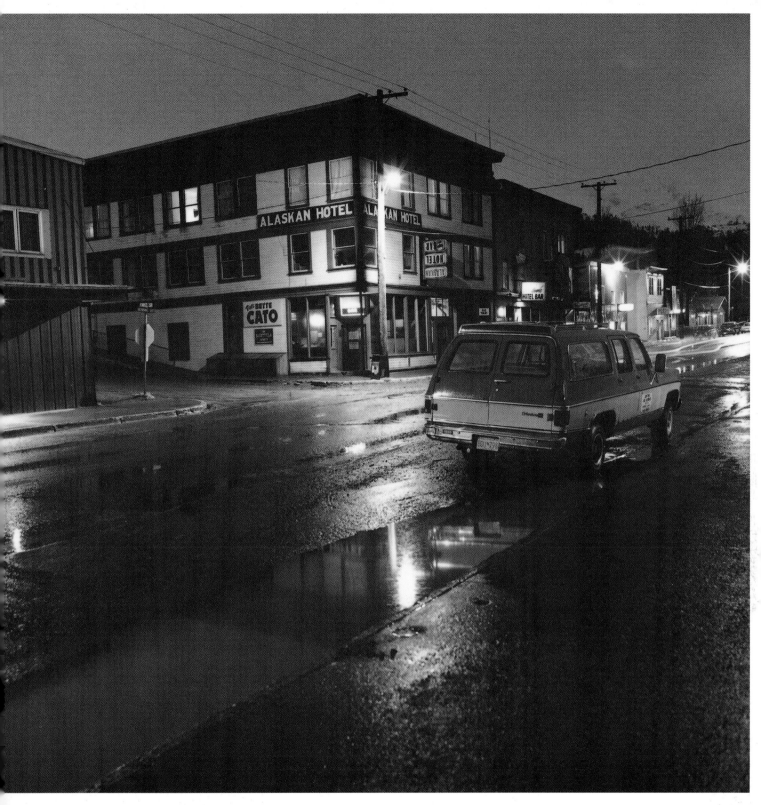

Left This image was made at 1/4 second and I panned the camera with the motion of the woman. I was checking into a hotel on Broadway in Times Square, and in that situation the light is everywhere.

Above Cordova, Alaska

This image, made in a very light rain, took 45 minutes to expose. It is a great example of using compensating developer to obtain the most detail possible. The film was Ilford HP5+ and the ISO setting 200. I processed this in Ilford Perceptol at a dilution of 1:3 for 20 minutes. In an enlarged copy of this image, you can read the posters on the wall inside the Alaskan Hotel and see the treads on the tire of the car. Using a 50mm lens on my Hasselblad gave me great depth of field so that I did not have to crop the foreground, which would have been out of focus with a normal lens.

Above Some Bunny Lost His Head
Every year in New York City the Halloween Parade
is a great subject. I have been photographing the
parade for eight years now, and this is one of my
favorite images. It was taken down a dark street,
and the exposure required that I lean on the
person standing next to me in order to ensure
some degree of sharpness in the image.

Right North Beach, San Francisco
The Condor Club is where topless dancing
started, and for a long time the area was covered
with nightclubs. The entire Beat generation was
cultivated around the corner at City Lights
Bookstore and various jazz clubs in the area. For
this type of photography, I expose Kodak T-Max
P3200 film at an ISO of 1200, and then instead of
regular film developer I use Kodak DEKTOL (a
paper developer) for 3 minutes with constant
agitation. It gives the finished print a charcoal
quality without increasing the contrast or the
grain very much.

Left Made with a film camera and ISO 800 film, this image shows a difficult backlighting situation where the camera meter is trying to accommodate all the light sources. In this situation, you need to determine what is the most important subject for you in the photograph, and use spot-metering techniques to obtain the exposure you are looking for.

Right This image shows a parade. Here, the camera was panned with the movement of the floats to give a painting-with-color look. Use the matrix metering in the camera and ISO 800 color negative film, and it's hard not to get an interesting image with proper exposure. You will find that you will expose a lot of film.

Below left This is a digital capture, with some camera panning when the photograph was taken to add interest and a painterly effect.

Below right This is a digital photograph using a slower shutter speed to allow the dancers' movement to be the main compositional issue.

Creating Movement

In night photography, many of the exposures are extended because we need the information the longer exposure provides. With this assignment, try to use the natural movement that occurs with a longer exposure for added interest in the final image.

Aim of Assignment

One way to make an image more exciting is to introduce motion into it. Another way is to find a location where the movement in the scene will add interest to the photograph you are making. Because you are working at night, long exposures can be made either by using the natural movement in the scene, or by physically moving the camera to create your own motion and interest.

Equipment

- 35 mm camera
- light meter
- cable release and tripod
- ball head and tripod with calibrations for recording movement
- exposure timer

What to Do

Meter the scene using the techniques described on page 50. Make a static exposure so that you will have a record of how the scene looked unaltered. Using your tripod and ball head, carefully rotate the tripod head by set intervals. (It's best if your tripod and head combination have markings for 360°, which will help you repeat the photograph or judge your movement more easily.) Make a practice exposure by moving the camera 5° to the right, then 5° more, then 5° more. Make sure you keep your exposure the same for each stop on the movement, using your timing device. When you do your practice exposure, check to make sure that when you rotate your tripod head the camera remains level, so that your horizon line or other significant compositional element does not do the unexpected after you have had the film processed.

Top This image was made with a digital camera with the ISO set at 320. Exposure time was 8 seconds. The bridge is enhanced by the landing plane.

Middle This view of the bridge over the Charles River in Cambridge, Massachusetts, was made by keeping the camera still.

Bottom This image was created by using the degree marks on the tripod head to move the camera 5 degrees to the right during the exposure. The movement helped to change the static scene in the middle into one where boats, rather than the buildings, appear on the river, breaking the rules by changing cement and glass into nautical vessels.

Left This photograph was made on color infrared film with a yellow filter over the lens. Exposure time was 20 seconds. As the picture was being exposed, a helicopter flew in to land on the building across the river. The camera froze the helicopter in a great pattern in the sky, adding interest to the image.

Stage

Photographing artists on stage is an exciting and rewarding field of night and low-light photography—but be aware that this is the artist's stage, not the photographer's, so the image-maker must remain out of the way and out of sight.

Aim of Assignment

To capture the atmosphere of a live performance on stage, in a situation where the contrast can be extreme, varying between single points of light and enough lights to "wash" an entire stage. Make sure that you use a spot meter, or the spot-metering mode on your camera to get more accurate results.

Equipment

- 35mm camera
- wide-aperture zoom lenses such as 80 – 200mm f/2.8 and 28–70mm f2.8
- color negative ISO 400–1600 film
- black and white ISO 400–1600 or 3200 film
- spot meter
- monopod and cable release
- flashlight

What to Do

In this case, preparation is all-important, since you do not want to disturb or distract the artist from his or her onstage performance. Have a couple of plastic food bags ready, one for exposed film, the other for non-exposed film, and take all films to be used out of the boxes ready to load in to your camera. A second camera body, loaded with either the same film or perhaps black-and-white, can expand your creative options.

Shoot at the highest possible shutter speed that you can obtain from your lens; this will help ensure sharp images with less camera shake. This is the perfect place to shoot color negative film since it is the most tolerant of underexposure and is available at very high speed ISO. Suggested starting exposures are:

- 400 f/8 at 1/250 second in spotlight, or f/4 at 1/125 second under floodlighting
- 1600 f/16 at 1/250 second in spotlight, or f/8 at 1/125 second under floodlighting

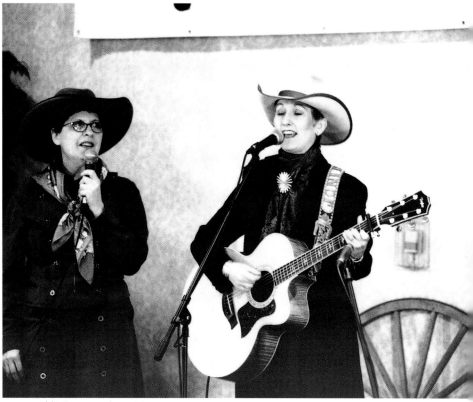

Above For this image 1600 ISO film speed was used. The picture looks a little muddy and was difficult to print. Look at the white hat, and you can see it's very difficult to separate the tones from those of the background; the top of the guitar is also washed out.

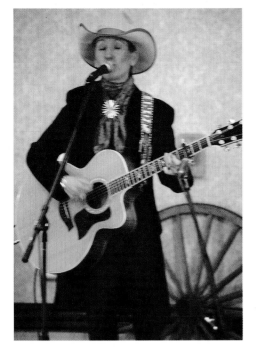

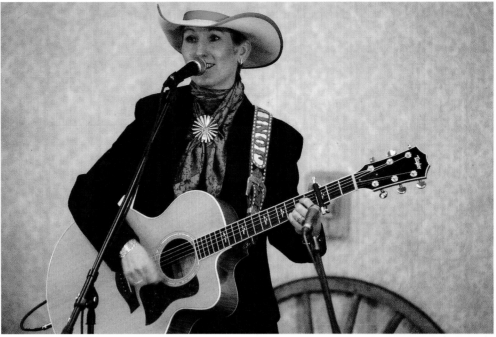

Above In this example you can see the effects of slow shutter speeds, even at 1/60 of a second. My general rule for using any telephoto lenses is that you should not shoot with a shutter speed that is slower than the focal length of the lens—on a 80–200mm lens, the slowest shutter speed you should use is 1/200 second for sharp images.

Top right This is a very exposed sharp image of the artist on stage, made with Fuji's new 800-speed color negative film, a great choice.

Right Sometimes it's nice to be able to include a little "local color" in the final image—the hat in the lower right-hand corner tells the cowboy story here.

Left Here, the film used was ISO 400 and was pushed in the processing to have an effective film speed of 1600. When you push black-and-white film, the contrast is much higher. In this case the push-processing helped to separate the white of the singer's hat from the white background and gave more tonality to the face of the guitar, enabling the viewer to read the name "Joni" in the guitar strap.

Fireworks

We all love fireworks, with their noise and variety of colors. We may not be able to reproduce the noise, but we can certainly capture the colors.

Aim of Assignment

To capture the colors and shapes of fireworks at night, and to boost or otherwise alter the colors for maximum impact.

Equipment

- any camera
- standard lens
- ISO 200 film
- cable release and tripod

What to Do

If you are going out to capture fireworks, make sure you arrive early so that you can set up your tripod in a great location. It's always best to be directly under the launching, but make safety your first concern in this issue. It also makes interesting imagery to get away and show some of the landscape in the final image. It's very hard to judge when fireworks will be launched, so be at the ready. Having your camera on a tripod and using a cable release means you can focus on the event, rather than which button to push on the camera. The best pictures will be those taken after it gets dark.

You can adjust the color balance of a digital camera or use tungsten film to change the color. It's difficult to predict what colors the fireworks will be, so leave the color balance on normal for digital capture. If you want more trails and movement, use a small aperture and a longer shutter speed. A lower-speed film will produce more brilliant colors; faster film will stop the action better, but the colors will not be as saturated.

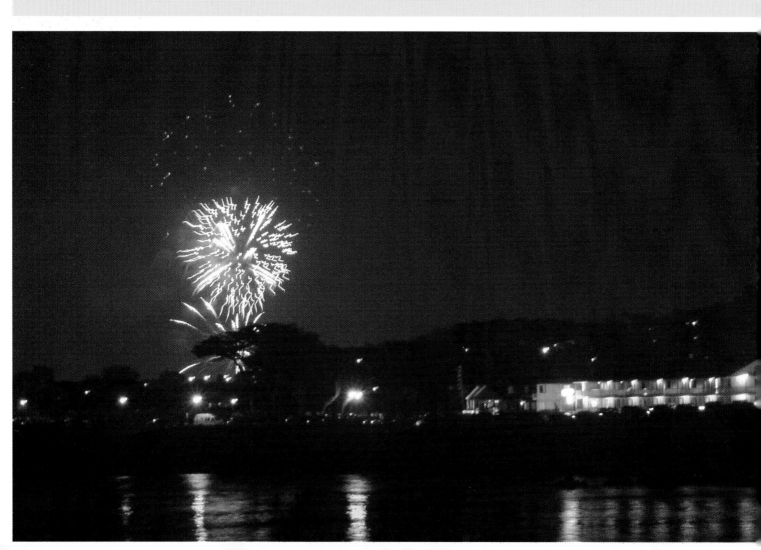

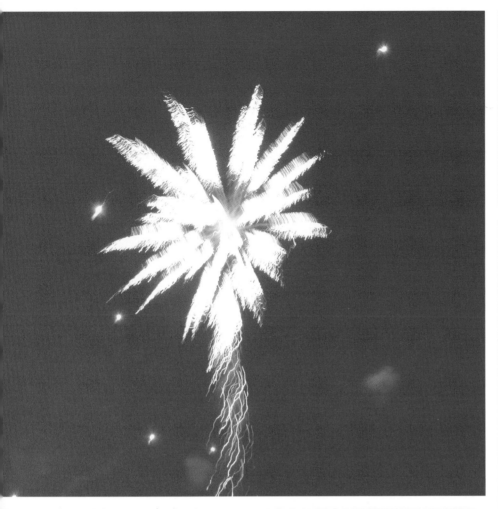

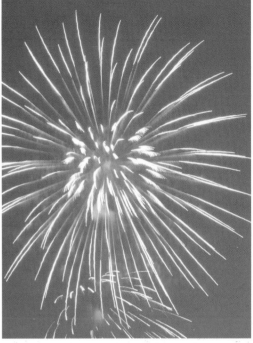

Above Here, the digital color balance was changed to 3000°K for a deep blue sky.

Opposite and left A faraway vantage point helps the viewer see the location instead of just the colors from the fireworks. Before the event, try looking for the best possible vantage point.

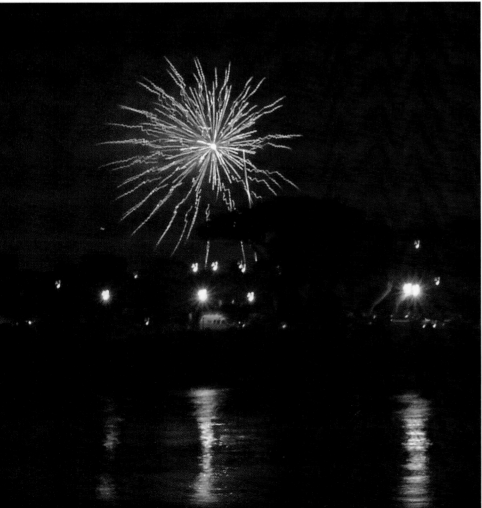

Painting with Light

When no light is present but you are still interested in making a picture, you can "paint with light." This idea works both in the studio and out in the landscape, and the tools that you need are very simple and inexpensive.

Aim of Assignment

To work carefully in a very dark environment, find the subject in the scene that you are interested in painting with light, and then light it with a small portable strobe, flash unit, or flashlight.

Equipment

- any camera
- any film
- tripod
- portable strobe, flash unit, flashlight, or torch

What to Do

Set your camera to an aperture at which you want the depth of field to be. If you want limited depth of field, set it very wide at f/2.8 or f/4; if you want maximum depth of field, set the lens for f/11 or f/16. In the dark environment with the camera lens open, walk around the object painting with the lights. You will need to do some test exposures with the painting to determine exactly how much light you would like on the subject.

If you are working in a studio, it is best to be able to darken the room completely and work with a flashlight—wear black or dark clothing and gloves and move quickly, so you will not appear in the finished image. If you are interested in adding odd or different colors to the scene you can put filters over the flashlight.

You can modify this assignment to paint with color, splattered on the film and finished paper as can be seen in the examples on these pages. To achieve this effect, find colors that you like, put a very slow speed film in the camera, and just have fun—spin the camera, move in close to the colors and then back, use your zoom lens on your 35mm camera to create blurred effects on the edges and sharpness in the center, but most of all have fun. To ensure success, make sure you shoot a lot of film.

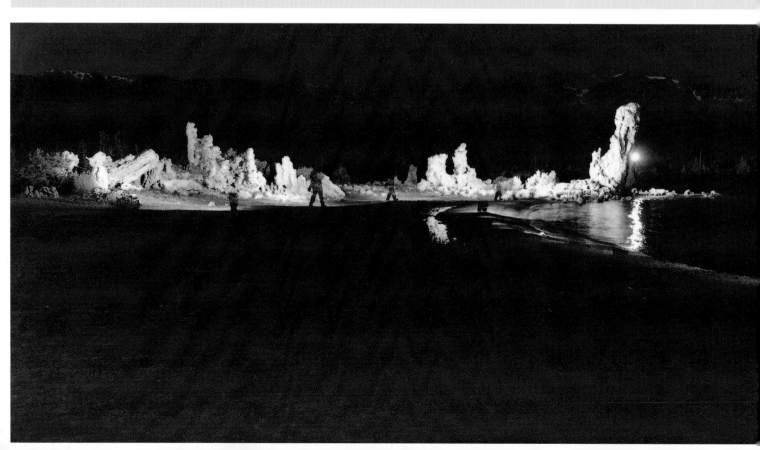

Above Stump and White Root, Northern California Coast

This is one of my favorite night pictures. The exposure was one hour and the sky was misty and rainy, which gave me the possibility of a very white sky in the finished print. I painted the white root with a small flashlight for 30 minutes as I waited for the film to expose. Several times during the exposure the waves came up about a foot over my tripod legs. I hoped that the exposure would be sharp, but had no way of knowing until I processed the film.

Left Mono Lake, Halloween 1996

Here, a workshop group used small portable strobes with 200-watt-second flash heads to paint the famous tuffs with light. We also painted a light in the water. Because of proper film processing and the illumination of the moon, the Sierra Nevada Mountains are visible in the background with a faint snow cap, and we appear as ghosts in the finished image.

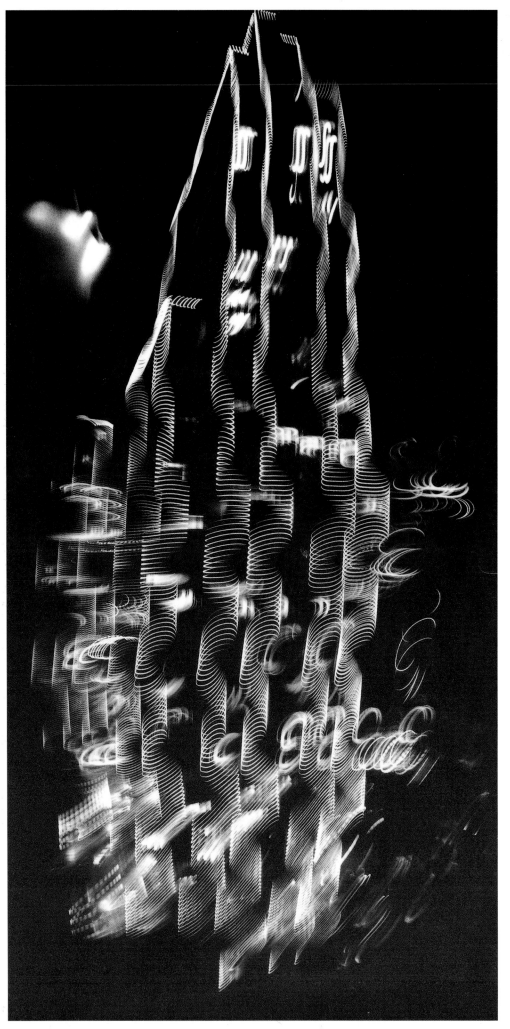

Above This image was taken with a camera with
a rotating lens. As the picture was being made,
I spun the camera above my head. I like the idea
of "splattering color" as a final image. As you can
imagine, not all of these are successful, and I
recommend shooting a lot of film in order to get
the best results.

Left San Francisco from the 24th Floor
San Francisco is a beautiful place in the winter,
with most of the downtown buildings illuminated
with strings of lights. I become very nervous when
I am up that high in any building in San Francisco,
because of the earthquake possibility, and was
trying to express my feelings on this image, made
using a WideLux camera with a rotating lens.

Above These two examples were made with two different cameras. Each time, I moved the camera as the 12-second exposure was made on Polaroid SX-70 film with 600 ASA.

Fire

Making images of fire is challenging, but a well-exposed and composed image is exciting to view. These can range from a blazing building to birthday candles.

Aim of Assignment

The aim of this assignment is to help you be ready when an opportunity to photograph fire is at hand.

Equipment

- 35mm camera with 28–80 zoom lens
- tripod or monopod

What to Do

If you are photographing fire, you will need the fastest color negative film that you have available. When photographing an event, such as a family gathering or a birthday, it's best to use a tripod, if you have one that is small enough or handy to use. When photographing outdoors, try to make a tripod out of your arms: balance them both on your chest, breath in and snap the shutter. You should be able to use an ISO 800 speed film and snap the shutter at 1/4 of a second with this technique. If you can't use do this, try to find something of substance to rest the camera against so that you don't have to use a tripod, which can be bulky.

Above This image of candles and a cross was shot on ISO 800 color negative film. The image was underexposed by 2 stops to keep detail in the flame, adding just a hint of the cross in the background.

Right This image was shot on Polaroid film, with the camera making the exposure decision. Polaroid is great for this type of occasion, as it provides an immediate way to share memories.

Above Camera meters cannot "see" the exposure for recording a fire, since some of the information contained in the fire is out of the spectrum of the meter's range. To achieve accurate, exciting results, use the bracketing method, as shown here.

In this proof sheet the exposures started at f/5.6 at 1/8 second for #1 (the exposure my Luna-Pro meter suggested I start at). I then bracketed down in full stops for the following exposures: #2, f/5.6 at 1/4 second; #3, f/5.6 at 1/4 second; #4, f/5.6 at 1 second; #5, f/4.0 at 1 second; #6, f/2.8 at 1 second; #7, f/2.8 at 2 seconds; #8, f/2.8 at 4 seconds; #9, f/2.8 at 8 seconds.

I prefer #4, which was 3 stops overexposed by the meter reading but gives the most interesting look to the fire.

Top right In fire emergencies you can often use a receding line like the yellow of the hose to help draw attention to the center of the picture.

Middle right A wide-angle view tells the story of the bravery of the fire-fighting brigade.

Bottom right By not using a flash and just letting the red from the scene illuminate the control panel of the trucks, an eerie, color fills the photograph and makes us feel the action of the fire.

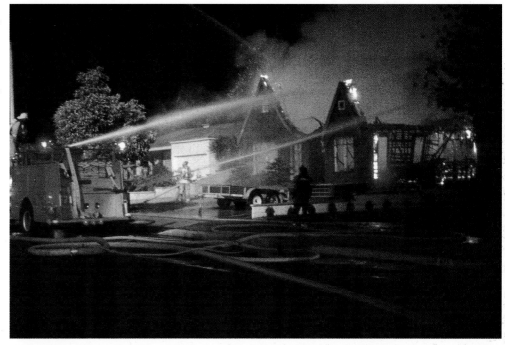

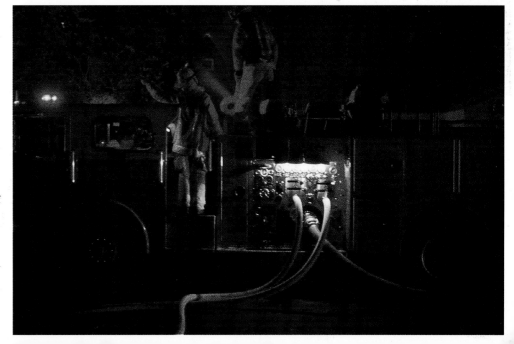

Snow

It's snowing! What a great opportunity to create images of a different type in the landscape. Snow can reflect a lot of light, but without any of the harsh shadows that are unavoidable with the sun, just because it's snowing and it's dark, there is no reason to leave your camera in the case.

Aim of Assignment

This assignment should motivate you to get out and take photographs in the snow. In these conditions, especially under a full moon, the light is very different, shadows are soft, and scenes take on a surreal appearance.

Equipment

- any camera
- tripod and cable release
- flashlight

What to Do

It is a good idea to wear gloves, as tripod legs get very cold when exposed to the elements for any length of time. Also, make sure that your feet are dry and that you are adequately protected against the cold.

When photographing snow there are some very exciting creative possibilities—and also the distinct possibility of frostbite or exposure. A snow-covered forest under the moon or stars can be a magical place, and with a good composition, you can "reverse" the landscape.

Left This image was made on tungsten-balanced E-6 film, which gave the scene a very blue cast. This can be used to creative advantage in conveying how desperately cold it really was. The exposure was f/4.0 at 15 minutes. During the last 30 seconds of the exposure the scene was illuminated, giving the final image a spotlit appearance.

Above This image, made with a 2 1/4 roll film camera, was exposed on Fuji ISO 800 film. One thing that was important to me in the creation was to capture the path that the moonlight made between the trees. It was also important not to include the moon—if this were to be included in the image, the exposure would have to be 1/4 second or less, since the moon will not appear sharp at any slower shutter speeds.

Metering

The single most important thing that a photographer can understand about night photography is how to meter the scene properly. In night photography, exposure can be lengthy, and proper metering ensures the photographer a useable exposure in the shortest possible time. Techniques like bracketing can be useless if the scene is as dark as a 4-hour exposure might require. If you tried to bracket, the second bracket would be 8 hours long and the sun would most likely be up by that time.

Aim of Assignment

Light is the essence of photography. Being able to measure that light accurately and translate it properly to a photographic exposure is the basis of this book. In some of the other assignments there have been specific goals in mind, such as movement or photographing buildings, in the image. Learning how your meter "sees" light and how that information is translated to film is the basis of learning to meter. This assignment covers conventional metering and spot metering. It shows how meters "average" exposures and reveals the results of these metering techniques.

Equipment

- any camera
- wide-angle lens
- 50mm lens
- spot meter
- tripod and cable release

What to Do

Set up your camera (on a tripod) in a low-light scene such as a storefront window with lamps or lights in plain view. Put your camera to your eye from the same position as you will be photographing and survey the scene. If you can set your camera to the spot meter mode do that; if not, just use matrix mode. Make notes on a pad of paper or just try to remember them in your head. You will notice that the reading is much higher when you aim at the lights than when you aim under the table. Record all of those readings and average your exposure. Expose a few frames at that exposure and note the number of the frames. With the camera on the tripod, do a series of exposures in the spot meter mode, first aiming the camera into the shadows, recording what the meter reads. Next, aim directly at one of the illuminated lights, again recording what the meter reads. Use the camera on matrix or aperture priority, recording what the meter reads.

Take the reading that you got for the first and second steps and average them together, for example, if the first step said f/8 at 1 second, and the second step said f/8 at 1/125 second, an average reading would be f/8 between 1/8 and 1/15th second.

After you have the film processed, look at the images. You should find that where you were metering without the inclusion of the bright light source you will have adequate information in the image. Those pictures that were taken that included the bright light source will be underexposed in the main subject area.

If you are using color negative film for this assignment you will not be able to have the film processed conventionally, as all color negative (C-41) machines have a sensor that reads print density and will look at an underexposed negative and print it accordingly. This will result in a very grainy print. If you want to do this assignment with color negative film, have the film processed by a professional color lab and ask them for a proof sheet of the negatives.

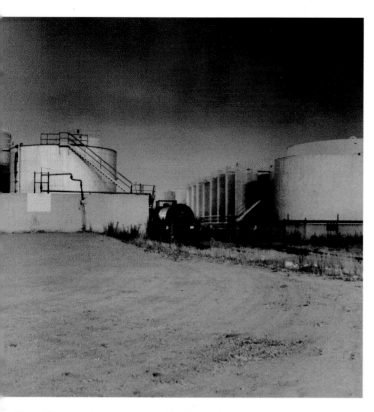

Above The most important part of the image for me was to get a very "steely" feel to the storage tanks. The exposure was calibrated off the tanks, which is almost 18% gray.

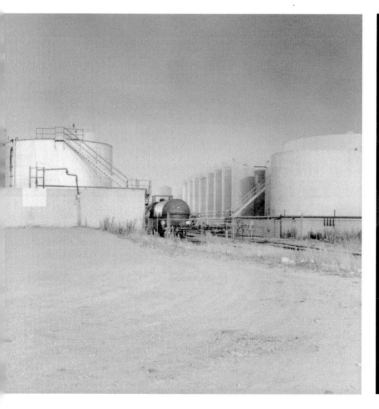

Above In this example the scene was metered off of the black on the railroad car. The meter "thought" that the black of the train car was 18 percent gray, which caused the entire rest of the picture to be very over exposed.

Above This example shows extreme underexposure. It's important to remember that all in-camera meters are calibrated to 18 percent gray, as are hand held exposure meters.

Limited Depth of Field

Depth of field is one of the most creative tools a photographer has in his or her kit. At night this technique can drastically improve an image. Limited depth of field means that you are using your camera lens at its widest possible aperture and allowing optical principles to make the rest of the image greatly out of focus.

Aim of Assignment

When our eyes see something, they see with unlimited depth of field. The aim of this assignment is to allow you to become comfortable with using limited depth of field —one of the most important creative options that the camera allows us, be it a digital capture or a well-crafted black-and-white negative. In this assignment we will be using limited depth of field to help isolate the most important subject in the composition and make our ideas clearer to our viewers.

Equipment

● any non-digital camera
● standard lens
● wide-angle lens
● ISO 800 film
● tripod and cable release

What to Do

Expose all of your images at the widest possible aperture. As a second experiment, use a wide-angle lens at the widest possible aperture of the same scene and compare the results. If you can rent a f/1.0 lens, try it for a weekend, do the same tests as above, and compare your results. Even though these lenses are very expensive, I find them important in my kit, allowing me to make images where no other lens can capture a scene with such beautiful qualities. All lenses work well with this technique, but specialist lenses are made just for limited depth of field. Leica, Canon, and Nikon all produce lenses of normal focal lengths with apertures of f/1.0. Using high-speed film such as ISO 800 allows shutter speeds in the 1/30–1/60 second range, assuring sharp pictures. The depth of field is very limited with the lens wide open, and extreme care must be taken when focusing or using the auto-focus feature.

Left Using limited depth of field you can create abstracts and sharp images, or let color or a sharply focused element in the image tell the story, such as with this Christmas ornament, which was exposed at f/1.0.

Above This simple picture of a
bicycle leaning against the fence is
a good example of limited depth of
field. You can see that the bike is in
focus, yet the fence that is just
behind the bike is out of focus,
drawing attention to the bike and
not letting the fence distract from
the image. Exposed at f/1.0.

Right Shot with a Canon f/1.0 lens
and looking straight up at this pizza
sign, this image demonstrates how
little depth of field is available from
this type of optic. If you look closely
you can even see that not only
looking up shows the limited depth
of field, but also the angle of the
sign as it is anchored to the wall.

High Contrast

One option that photographers use very rarely is a high-contrast or ortho film at night. It is limited by the fact that the speed of the film is very slow—round ISO 12—but the results can be very dramatic.

Aim of Assignment

Using the tools that are available to us is one thing that sets us apart from the average picture taker. Creating images in high contrast is a fairly radical approach, but sometimes all that we are interested in is a very black-and-white image. The gray tones are not important to certain compositions. Being able to use high-contrast film can help us create those special, creative images that cannot be accomplished with standard continuous-tone film.

Equipment

- any camera
- ortho film
- any lens
- tripod

What to Do

Look for compositions where you do not have a lot of direct lights in the scene to be photographed. In this case it might be best to bracket your exposures, since this is a very untraditional representation of what reality looks like.

Above This is a snapshot showing the scene. It was made with ISO 400 film and the exposure was f/1.0 at 1/60 second. Use this image for a reference when you look at the rest of the pictures.

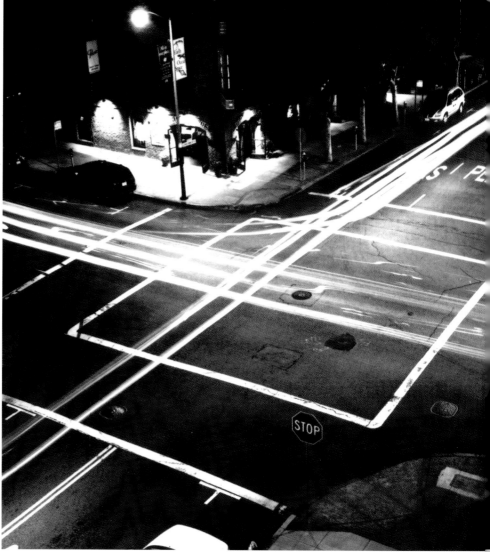

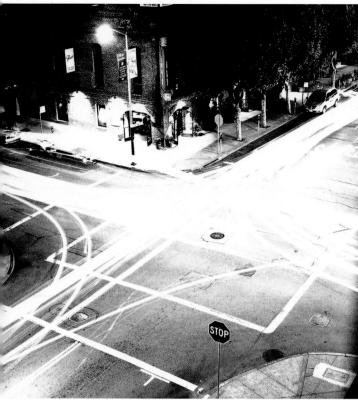

Above Keep your eye on the stop sign in the next three images. In this image the car lights make very straight white lines, and there is good tonality in the street. The building at the back of the scene shows little or no detail and you can see the effect that ortho film has. This was a 5-minute exposure.

Above right The stop sign appears to have the same density in this 10-minute exposure. The road washes out because of traffic and the lights from the cars and buses. I find when I stay in very noisy hotels, that photography helps me to get past the noise and into a more creative space.

Right The stop sign has about the same density of gray, but the lights from the traffic in this 20-minute exposure completely wipe out any detail that might be available in the roadway.

Left This was made with my Hasselblad camera on a tripod from a hotel window. The exposure was what my Luna-Pro light meter told me it should be, f/4.0 at 1 minute. You can see that the stop sign looks a little underexposed, and there is no detail in the building in the back of the scene. High-contrast or ortho film has no middle values of gray, which makes the image very black and white in the finished print.

Monuments

Frequently we find ourselves in front of great national treasures or monuments and want to record them. A picture taken at night can make an interesting alternative to a daytime shot.

Aim of Assignment

The aim of this assignment is to give the photographer confidence to photograph buildings at night—practice makes perfect.

Equipment

- any camera
- color negative or black-and-white film
- tripod

What to Do

When an architect designs a building, he or she understands that the building will be seen at night as well as during the day. Whenever you approach a beautiful building, the first impression is often not the most creative, expressive image of that building. When I am asked to photograph a building or monument at night, I always go first without my camera. If this is not possible, there are a few tricks you can use to make sure that you get the best possible image.

Firstly, walk around the entire building to make sure of the optimal camera position. Move your head up and down, lie down on the ground, or try to find a point of view that is elevated. Some of the best angles for photography hide in the most unsuspecting places. Finally, as you are looking at the monument or building, make sure you notice the background and see whether you can incorporate it into the photograph or you need a point of view that helps you eliminate any distractions in the scene from the picture.

If you choose to bracket, do so with the shutter speeds set for any fountains. Water at 1/4 second has a very nervous quality where when the shutter speeds run into seconds, and the feeling of the image can be one of complete movement. Meter from the water and then overexpose the image by one stop. Suggested starting exposures: ISO 200, f/5.6 I at 1/4 second; ISO 800, f/5.6 at 1/15 second

If you use black-and-white film, normal processing is recommended, as the contrast from the surrounding lights is extreme.

Above Las Vegas offers many monuments and large buildings to photograph. It is almost impossible to capture these with a flash, so your best choice is an extended exposure. In this case, I chose to include the taxis in the foreground to help better tell the story of the building and the activity that surrounds it.

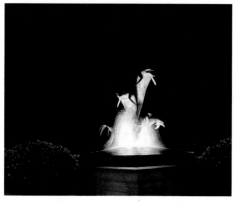

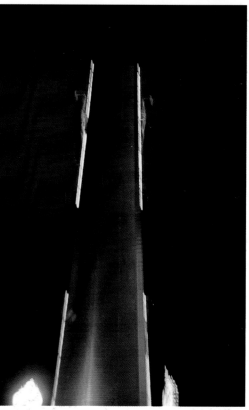

Above Using the amazing range of latitude of color negative film allowed this image to have a very short exposure, where even individual drops of water can be seen.

Left When photographing buildings that are lit with floodlights on color negative film, underexpose the film by 1–2 stops. That will give a very rich texture to the white and help block out the background, which could be distracting. Make sure your camera position tells the story of the building.

Right Traditionally signs are photographed straight on. This angle was around the side and it gave the final image a very abstract look, just pillars of light that shoot skyward. This image was created on color transparency film to help magnify the contrast between the colors and the night sky.

Silhouettes and Strong Backlighting

Silhouettes make for great images and allow the night photographer an opportunity to maybe take a peek into some unique areas. These images are traditionally strongly backlit. I like black-and-white film for this type of image, as it adds to the interest and mystery of the scene.

Aim of Assignment

This assignment is designed to teach you to use strong backlighting in the night environment in order to create dynamic compositions that might not necessarily be full-range images. Silhouettes create tension and drama in photographs because of the unknown qualities of the composition.

Transparency film will work well here because of the extreme contrast that it creates. Wide angle or telephoto lens can be employed; if you choose a high speed film a tripod might not be necessary to create the effects you are after. Camera position is of the utmost importance in placing the dramatic compositional elements in the proper place.

Equipment

- Wide-angle or telephoto lens
- transparency film

What to Do

Use matrix metering on your camera and exposure for the highlights. Shadow detail is not important to you in this case. Using faster speed film will allow you to work without a tripod.

Photographing silhouettes and using strong backlighting adds interest to your photographs, and working at night makes photographing this type of subject matter very easy. One of the hardest things to do with a silhouette is to isolate the subject from the background. When you are working at

night, you can use the cover of darkness as the dark contrast for the subject. In a reversal of this, you can also find a strong backlight and place the subject in front of the light. Because you are photographing at night, very little detail will be rendered in the subject.

You can use your standard film or digital camera for this assignment and it would be best to use a tripod. Select a film with a slow ISO or set the digital camera to an ISO of 80. One hint here is to make sure that you always use a lens shade on this type of photograph. If you are in doubt as to whether you will get lens flare in the image, lean you head around and look at the lens to check for flare.

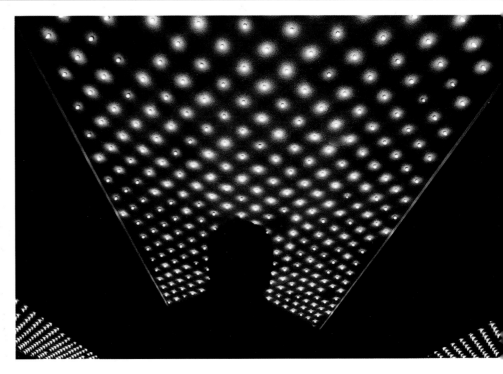

Right Using a wide-angle lens and color transparency film for this shot gave me the greatest contrast and let me fulfill my visualization for the image. As I had no interest in retaining any detail in the back of the subject, the most important area to meter was the lights. The lack of detail helps create mystery in the finished photograph. The contrast of the color transparency film gives compositional help by creating negative space between the lightbulbs in the ceiling.

Above Legs, Chicago
I like to walk around with my camera and just see what I can find; and I particularly love store windows in big cities for subject matter. I allowed the matrix metering in my camera to calculate this exposure.

Right Arizona
This image reminds me of the Old West. There were some cardboard cutouts in this window, which made for a great scene. I metered off the window and did not expect any detail. This kind of image can come very close to a high-contrast ortho image.

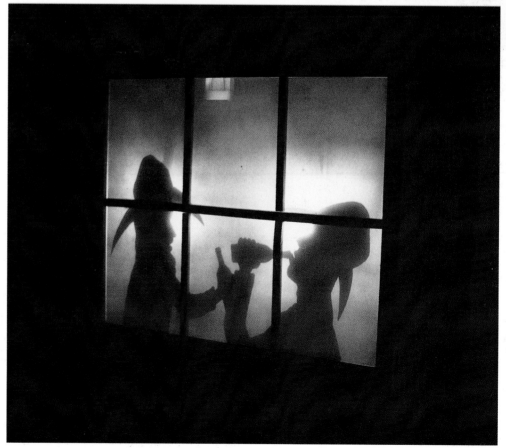

Amusement Parks

This is one of my favorite places to photograph at night. The colors are exciting and loud, and there are people and faces all over. You can look into the corners and the shadows and find some wonderful images, if you look hard enough.

Aim of Assignment

Amusements parks are an assault on our visual senses. Lights whirl, colors spin in front of us, people are laughing, some might even be ill. The aim of using the camera in amusement parks is to learn to translate those feelings, and emotions to film. Try to incorporate the lights into a picture that expresses your feelings at the time

Equipment

- 35mm, 2 ¼ camera, or digital camera
- wide-angle 24-35mm lens.
- color transparency, high-speed color negative, and black-and-white films

What to Do

Less equipment is better here, as you will have more freedom to move around. Make sure you carry model release forms for potential models to sign just in case you get something great and want to use it later. (You should not publish pictures without the subject's knowledge.)

Use the following exposures as a starting place: on ISO 400, f/4 at1/60 second; on ISO 1600, f/4 at 1/250 second.

Above Pig Alive

This image was made with my Leica camera and a 35mm f/2.0 lens. There is no flash in this picture, but having people in the front of the image with white shirts helps to give the appearance of a very well-lit scene. I metered off the gray on the wood that surrounds the largest hog you will ever see!

Right The lights from carnival rides can make for some pretty interesting compositions. In this case, a little camera motion gave the lights movement and character.

Far left By using a tripod you can capture some parts of the image sharp and allow the natural movement in the scene to be a creative element. The proper metering technique for this scene would be to average the exposure. While the background can be blurred, the sign at the front of the image needs to be in focus.

Left Using mirrors in the fun house to create self portraits is fun. Use a color negative film and average the exposure.

Infrared Films at Night

This is a very unusual application for these films. For the most part they are manufactured for scientific purposes, though they can create very untraditional-looking images.

Aim of Assignment

In the normal world, we do not see into the infrared spectrum of light. Infrared film is sensitive to, and can record, a wavelength that we cannot see. Using infrared film at night will create images that look different. The colors are different and some parts of the subject may even disappear.

Infrared film is a tool that will give your images that special something those not in the know will never achieve. This technique is also fun to experiment with. Enjoy the unpredictable results!

Equipment

- any camera
- infrared film
- wide-angle lens
- tripod and cable release

What to Do

First, you must load your camera in *total* darkness. If you fail to do this, your film will fog and your results will be less than satisfying. If you do not have a darkroom close by, then make sure you carry a changing bag in your camera bag to allow for total darkness when changing films. You should also keep a roll of black tape with you for taping the film canisters shut to avoid them opening and ruining the film.

Use the meter in your camera and bracket at least 3 stops on both sides of the suggested exposure to ensure success.

If you are traveling by plane, it's best not to take this film through any x-ray security check. It is best to find a local lab able to process your films, making sure to tell them it is infrared film, or carry the chemicals necessary to process it yourself.

Right This example was made with standard color negative film; use it as a reference when looking at the color infrared version, shown below.

Below Taken with Kodak color infrared film. The suggested ISO for this film is 200, but if ever there was a case for bracketing, infrared film wins the medal. Kodak recommends using a standard yellow filter over the lens; I suggest you try it with and without for different color effects and different results.

Opposite A black-and-white infrared image that was shot in Times Square in New York City. With infrared film you are photographing in a spectrum that we cannot see and mostly are photographing heat; that's why leaves look almost white (they are dense in the negative, resulting in white in the print). In daylight photography, I expose Kodak black-and-white infrared film at ISO 200 and use a dark red filter over the lens. For using this film at night I suggest using a starting ISO of 50 and leaving the red filter off the camera.

Neon

Neon images, found in many city environments, are best captured at night. This assignment shows you how to get the best results.

Aim of Assignment

This aim here is to capture the colors of neon with confidence and creativity.

Equipment

- camera with a very wide-angle lens
- tripod
- lens hood to minimize glare (optional)

What to Do

The best time for photographing neon is twilight. If you shoot too early, the sign won't stand out enough from the ambient light. Too late, and there won't be enough ambient light to illuminate the sign. Also, if you have chosen a shot that silhouettes either the building or the sign against the sky, it is best to capture the image while the sky is still a deep blue. If the sky is black, the silhouette of the building will be lost.

Use a small aperture and a slow shutter speed. You are shooting a light source, and stray reflections inside the lens can cause "ghost images" of the sign to appear.

Many neon signs are animated. If your shutter speed is too fast, you will capture only part of the sign. A shutter speed of about 1 second is typically enough to ensure that all of the tubes come on at least once while the shutter is open. A notable exception to this rule is a sign that has a moving figure, such as a running horse. In such a case you would probably want to increase the shutter speed and capture only one set of the horse's legs.

If you are using slide film it is best to bracket exposures. Many meters are fooled by the brightness of the sign into underexposing the film.

Above Varsity Theater, Palo Alto, California
This shot shows the result of overexposure. The sign is unrealistically bright and its rich colors have been lost or washed out.

Left Orinda Theater, Orinda, California
The twilight sky silhouettes the building and sign, yet the sky is still dark enough to give the impression of night. Compare this shot with the one on page 123 and you will see the importance of shooting before the sky turns completely black.

Right Sebastiani theatre, Sonoma, California
The timing for this shot was a bit tricky. In the Sonoma area the sky darkens unusually quickly once the sun sets, so I metered the sky at very short intervals while I was shooting to make sure that I would get the image and exposure that I wanted.

Above This shot of the Rio shows the result of shooting too early in the evening. The sky is so light that it still looks like daytime.

Above right This shot was taken 20 minutes after the one above. The marquee is documented, but the photograph lacks the ambiance that a deep twilight sky would give it. Compare this shot with the one on page 120.

Right Another example of losing the ambiance of twilight and the silhouettes of the building.

Far right Another example of an overexposed image. The neon tubes have lost their color and they appear as hot white lines with a colored glow surrounding them.

Right California Theater, Berkeley, California This shot, also, shows the result of shooting a bit too early in the evening. The architectural details on the building are clear, but the marquee doesn't stand out as much as it could. A few minutes can make all the difference.

Left Paramount Theater, Oakland, California The theater's vertical sign is animated at one rate and the horizontal marquee animates at a different rate. Careful timing was required when shooting so that all of the neon tubes would come on at least once while the shutter was open.

Glossary

Agitation
Keeping the developer, stop bath, or fixer in a gentle, uniform motion while processing film or paper. Agitation helps to speed and achieve even development and prevent spotting or staining.

Ambient Light
The available light completely surrounding a subject. Light already existing in an indoor or outdoor setting that is not caused by any illumination supplied by the photographer.

Aperture
Lens opening. The opening in a camera lens through which light passes to expose the film. The size of aperture is either fixed or adjustable. Aperture size is usually calibrated in f-numbers-the larger the number, the smaller the lens opening.

Aperture Priority
An exposure mode on an automatic or autofocus camera that lets you set the aperture while the camera sets the shutter speed for proper exposure. If you change the aperture, or the light level changes, the shutter speed changes automatically.

B (Bulb) Setting
A shutter-speed setting on an adjustable camera that allows for time exposures. When set on B, the shutter will stay open as long as the shutter release button remains depressed.

Backlighting
Light coming from behind the subject, toward the camera lens, so that the subject stands out vividly against the background. Sometimes produces a silhouette effect.

Bracketing
Taking additional pictures of the subject through a range of exposures-both lighter and darker-when unsure of the correct exposure.

Color Balance
How a color film reproduces the colors of a scene. Color films are made to be exposed by light of a certain color quality such as daylight or tungsten. Color balance also refers to the reproduction of colors in color prints, which can be altered during the printing process.

Contrast
The range of difference in the light to dark areas of a negative, print, or slide (also called density); the brightness range of a subject or the scene lighting.

Contrast Grade
Numbers (usually 1-5) and names (soft, medium, hard, extra-hard, and ultrahard) of the contrast grades of photographic papers, to enable you to get good prints from negatives of different contrasts. Use a low-numbered or soft contrast paper with a high contrast negative to get a print that most closely resembles the original scene. Use a high-numbered or an extra-hard paper with a low-contrast negative to get a normal contrast paper.

Depth of Field
The amount of distance between the nearest and farthest objects that appear in acceptably sharp focus in a photograph. Depth of field depends on the lens opening, the focal length of the lens, and the distance from the lens to the subject.

Emulsion
Micro-thin layers of gelatin on film in which light-sensitive ingredients are suspended; triggered by light to create a chemical reaction resulting in a photographic image.

Exposure
The quantity of light allowed to act on a photographic material; a product of the intensity (controlled by the lens opening) and the duration (controlled by the shutter speed or enlarging time) of light striking the film or paper.

Exposure Latitude
The range of camera exposures from underexposure to overexposure that will produce acceptable pictures from a specific film.

Exposure Meter
An instrument with a light-sensitive cell that measures the light reflected from or falling on a subject, used as an aid for selecting the exposure setting. The same as a light meter.

Film Speed
The sensitivity of a given film to light, indicated by a number such as ISO 200. The higher the number, the more sensitive or faster the film. Note: ISO stands for International Standards Organization.

f-Number
A number that indicates the size of the lens opening on an adjustable camera. The common f-numbers are f/1.4, f/2, f/2.8, f/4, f/5.6, f/8, f/11, f/16, and f/22. The larger the f-number, the smaller the lens opening. In this series, f/1.4 is the largest lens opening and f/22 is the smallest. Also called f-stops, they work in conjunction with shutter speeds to indicate exposure settings.

Focal Length
The distance between the film and the optical center of the lens when the lens is focused on infinity. The focal length of the lens on most adjustable cameras is marked in millimetres on the lens mount.

Focus
Adjustment of the distance setting on a lens to define the subject sharply.

High Contrast
A wide range of density in a print or negative.

Highlights
The brightest areas of a subject and the corresponding areas in a negative, a print, or a slide.

ISO Speed
The emulsion speed (sensitivity) of the film as determined by the standards of the International Standards Organization. In these standards, both arithmetic (ASA) and logarithmic (DIN) speed values are expressed in a single ISO term. For example, a film with a speed of ISO 100/21° would have a speed of ASA 100 or 21 DIN.

Lens Speed
The largest lens opening (smallest f-number) at which a lens can be set. A fast lens transmits more light and has a larger opening than a slow lens.

Negative
The developed film that contains a reversed tone image of the original scene.

Normal Lens
A lens that makes the image in a photograph appear in perspective similar to that of the original scene. A normal lens has a shorter focal length and a wider field of view than a telephoto lens, and a longer focal length and narrower field of view than a wide-angle lens.

Off-The-Film Metering
A meter which determines exposure by reading light reflected from the film during picture-taking.

Overexposure
A condition in which too much light reaches the film, producing a dense negative or a very light print or slide.

Panning
Moving the camera so that the image of a moving object remains in the same relative position in the viewfinder as you take a picture.

Program Exposure
An exposure mode on an automatic or autofocus camera that automatically sets both the aperture and the shutter speed for proper exposure.

Push Processing
Increasing the development time of a film to increase its effective speed (raising the ISO number for initial exposure) for low-light situations; forced development.

Rangefinder
A device included on many cameras as an aid in focusing.

Reciprocity
Most films are designed to be exposed within a certain range of exposure times-usually between 1/15 second to 1/1000 second. When exposure times fall outside of this range-becoming either significantly longer or shorter-a film's characteristics may change. Loss of effective film speed, contrast changes, and (with color films) color shifts are the three common results. These changes are called reciprocity effect.

Selective Focus
Choosing a lens opening that produces a shallow depth of field. Usually this is used to isolate a subject by causing most other elements in the scene to be blurred.

Shutter Priority
An exposure mode on an automatic or autofocus camera that lets you select the desired shutter speed; the camera sets the aperture for proper exposure. If you change the shutter speed, or the light level changes, the camera adjusts the aperture automatically.

Stopping Down
Changing the lens aperture to a smaller opening; for example, from f/8 to f/11.

Through-The-Lens Metering
Meter built into the camera determines exposure for the scene by reading light that passes through the lens during picture-taking.

Time Exposure
A comparatively long exposure made in seconds or minutes.

Transparency
A positive photographic image on film, viewed or projected by transmitted light (light shining through film).

Tripod
A three-legged supporting stand used to hold the camera steady. Especially useful when using slow shutter speeds and/or telephoto lenses.

Tungsten Light
Light from regular room lamps and ceiling fixtures, not fluorescent.

Underexposure
A condition in which too little light reaches the film, producing a thin negative, a dark slide, or a muddy-looking print.

Variable-Contrast Paper
Photographic paper that provides different grades of contrast when exposed through special filters.

Wide-Angle Lens
A lens that has a shorter focal length and a wider field of view (includes more subject area) than a normal lens.

Zoom Lens
A lens in which you adjust the focal length over a wide range. In effect, this gives you lenses of many focal lengths.

Index

Acknowledgments

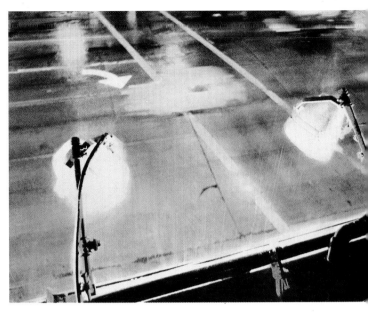

Author's Acknowledgments

There are many people who I would like to thank in the production of this book: this is my opportunity. I would like to thank Kate Kirby and Nicola Hodgson for their help and their patience in allowing this book to develop from a very rough outline to what is presented here.

Several photographic artists contributed images, text and ideas for this book—I would like to thank Dennis Keeley, Keith Johnson, Sam Davis, Martin A. Schmidt, and Marianne Rowe. Also due thanks are my wife, Wendi, for her help and encouragement, and her research for the chapters on scanning color negatives and digital cameras; Fry Photographics in Monterey, California, for processing all of my strange and unusual requests in a timely and totally professional manner; Irene Shields; Travis Johnson and Nick Heugo for color negative processing; Bert Parks and Dennis Nervig at Fuji Film USA; Les McLean for his wisdom, vision, and his single malt; my Great Dane, Elmer, for telling me when the Fed-X person had arrived and when it was time to take a break and play some tennis ball.

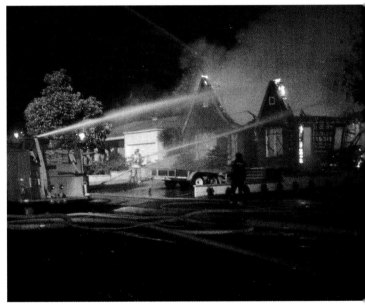

Publisher's Acknowledgments

Thanks to Michael Wicks for his photography of equipment on pages 46–50, 56–59; Chas at Focal Point, Exeter; Hama for their supply of accessories (tel: +44 1256 374700); Hasselblad for their supply of cameras and tripods; Robert White for their supply of meters; Intro2020 for their supply of filters.

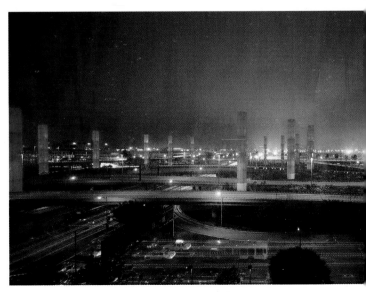